...panies the exhibition
Installations by Ten Japanese Artists
...n & Brad Thomas

...ontemporary Art at the College of Charleston and the Van Every/Smith
...llege organized this exhibition and residency program, in collaboration
...hitecture at the University of North Carolina-Charlotte, McColl Center
...University, Clemson Architecture Center in Charleston, and the Sum-
...t. The residencies and installations occurred in the fall of 2006, with
...the Sumter County Gallery of Art in April 2007. Funding for this col-
...by grants from the National Endowment for the Arts, the Henry Luce
...n Cultural Council. For a complete list of project sponsors, please refer

...emporary Art

...(except where noted)

...nenburg, Vermont
...sey.cofc.edu/fon.html

...tute of Contemporary Art

...06

FORC

This publication accom
Force of Nature: Site
Cocurated by Mark Sloa

The Halsey Institute of C
Galleries at Davidson Co
with the College of Arc
for Visual Art, Winthrop
ter County Gallery of A
a capstone exhibition at
laboration was provided
Foundation, and the Asia
to page 127.

Copublishers:

Halsey Institute of Cont
School of the Arts
College of Charleston
Charleston, South Carolina
29424
843 953 5680 T
843 953 7890 F
www.halsey.cofc.edu

Van Every/Smith Galleries
Davidson College
315 North Main Street
Davidson, North Carolina
28035
704 894 2519 T
704 894 2691 F
www.davidson.edu

All rights reserved. No part of
form or by any means withou
Art and the Van Every/Smith G

Photography: Mitchell Kearney
Book Design: Buff Ross
Copy Editor: Gerald Zeigerman
Printing: The Stinehour Press, Lu
Project web site: http://www.ha

ISBN: 978-1-890573-07-2
Available through the Halsey Insti

Front and back cover:
Noriko Ambe
Detail from *Dialogue with a Tree*, 20
Endpapers:
Motoi Yamamoto
Detail from *Labyrinth*, 2006

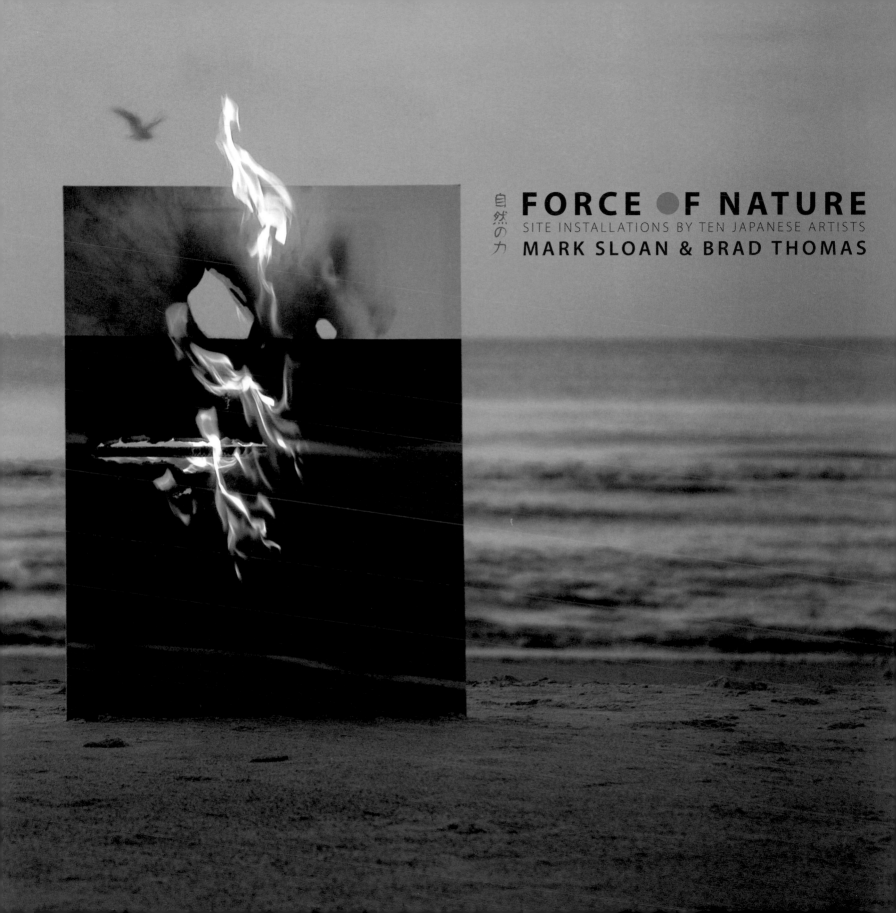

自然の力 **FORCE ●F NATURE**
SITE INSTALLATIONS BY TEN JAPANESE ARTISTS
MARK SLOAN & BRAD THOMAS

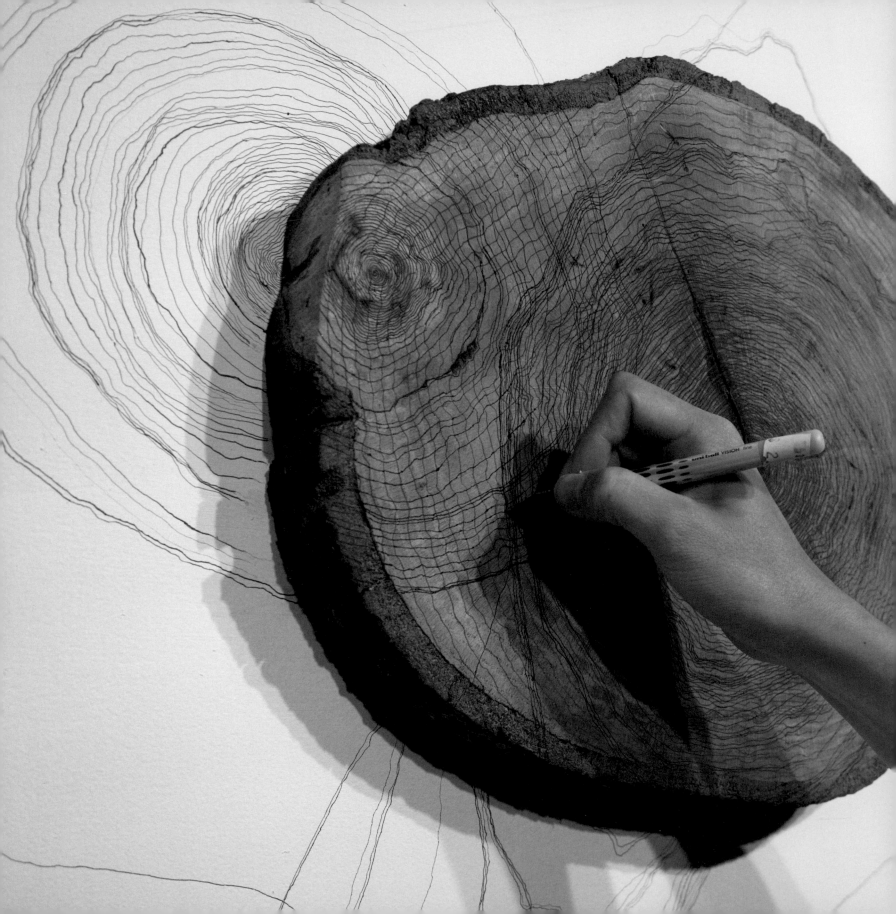

CONTENTS

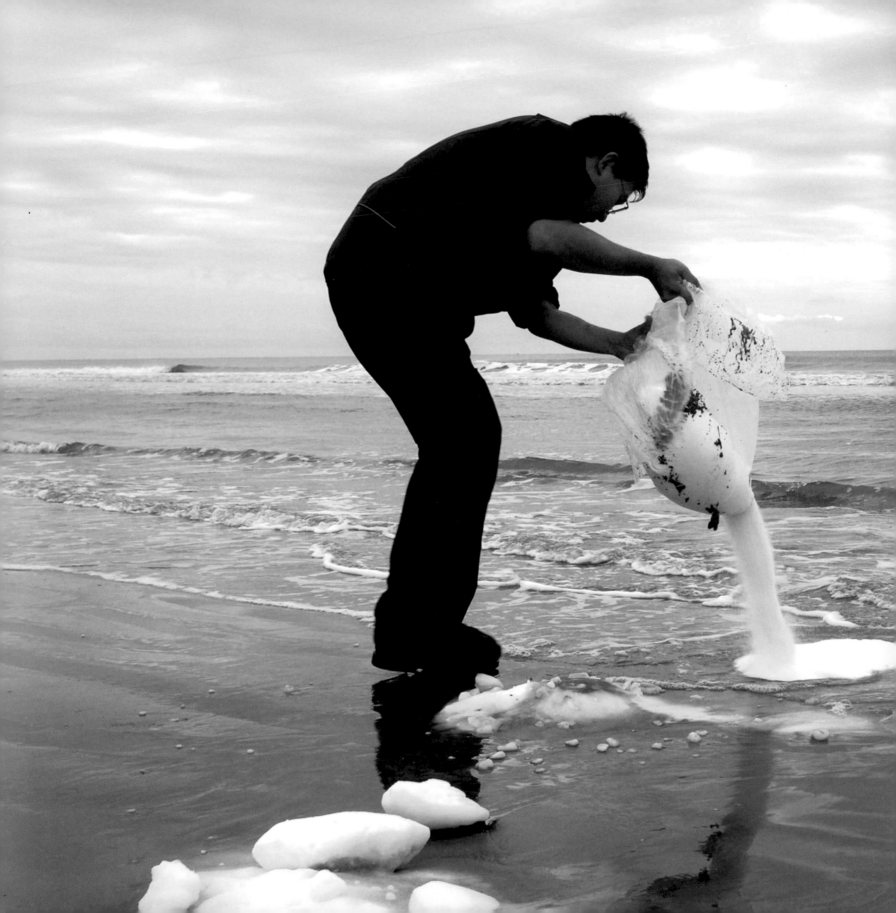

When we inhale, the air comes into the inner
world. When we exhale, the air
goes out to the outer world. The inner world is
limitless, and the outer
world is also limitless. We say "inner world" or
"outer world," but
actually
there is just one whole world.

"Zen Mind, Beginner's Mind," Shunryu Suzuki, 1970

我々が息をする時、その空気は体の内面のものとなる。
息をはく時、再度その空気は外界に属する。
我々の内面世界は無限である。
同じく外界も無限なのである。
我々はしばしば内や外などと区別をしたがる。
しかし、実はその様な差異は無く、
この世界は常に唯一ひとつだけ存在するのである。
禅への いざない

鈴木俊隆、1970

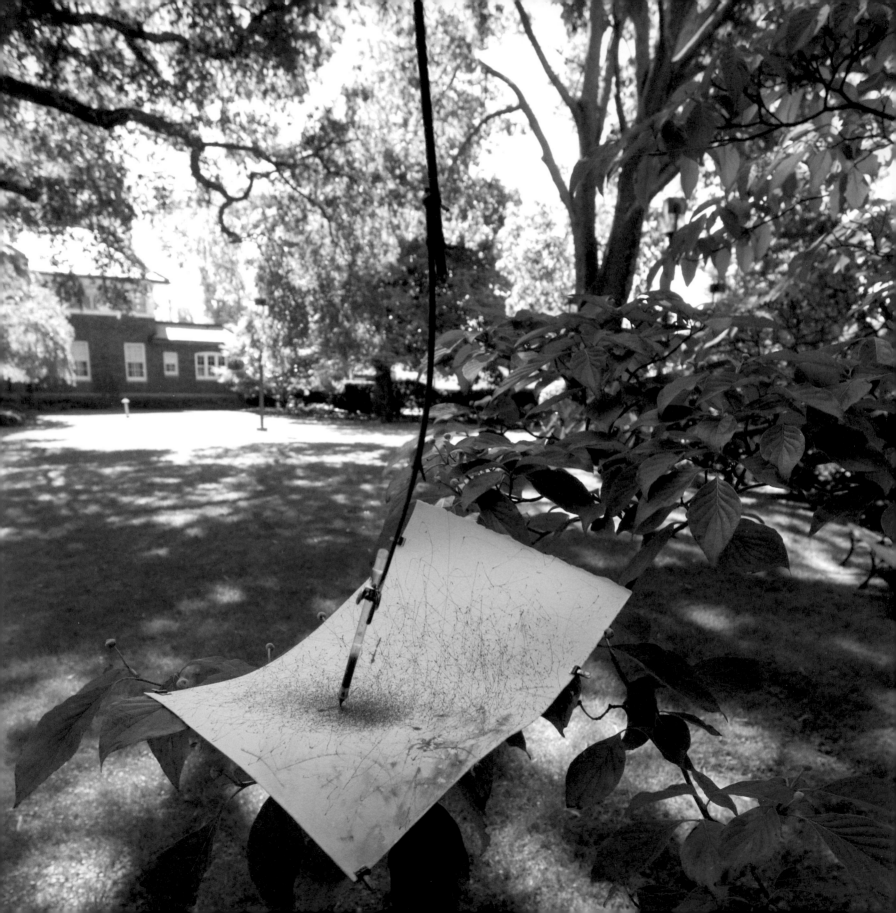

INTRODUCTION

brad thomas

I.

In retrospect, it seems fitting that the idea for *Force of Nature* was born on the banks of Lake Eden, site of the legendary Black Mountain College (1933–57). Nestled in the mountains of western North Carolina, the college was an intellectual incubator for some of the twentieth century's most influential artists, writers, and thinkers. Among them is John Cage, best remembered, perhaps, for organizing the first happenings, or performance-art events, that drew on elements of improvisation and chance—a concept developed through his study of Zen Buddhism with the renowned Japanese scholar D. T. Suzuki.

Some fifty years after Cage's groundbreaking experiments that merged Eastern spiritualism with Western aesthetic ideology, Mark Sloan and I sat there, gazing out over the peaceful, still water of Lake Eden . . . talking. Eventually, we got around to discussing ways in which our two institutions might coorganize an art exhibition. We were aware of our shared interest in Japanese art (something we had enthusiastically talked about that afternoon), and we both had a keen interest in commissioning artists to create new works. Perhaps influenced by the imaginative spirit of Black Mountain, or our own often ambitious dispositions, the designs for a straightforward art exhibition quickly became a multipronged residency program of extreme proportions.

The initial idea seemed simple enough: Invite contemporary Japanese artists to our respective institutions for a period of a few weeks to create works on-site using only indigenous natural materials. The only stipulations were that the artists had to be selected on the merits of past projects and that no preexisting works were to be shipped to the United States for exhibition. Having already organized several international exhibitions, we knew that the last provision would save a great deal of money.

II.

By November 2003, the funding was in place for us to travel to Japan and meet with some of the artists we had discovered through inquiries with other curators, magazine articles, and Internet searches. When we arrived in Tokyo, our guide, translator, and cultural expert, Noriko Fuku, welcomed us to her native country. A longtime friend and colleague, Noriko is a highly regarded curator of photography who has an impressive list of international exhibitions to her credit. Her presence throughout the research stage of our project proved invaluable, and much of the success of *Force of Nature* can be attributed to her assistance.

After initial interviews with some artists in Tokyo, the three of us traveled by bullet train to Kyoto, Osaka, and Fukuoka, collecting more names of suitable artists. Tempted by what we saw in the slides and catalogues that a variety of curators and gallery owners showed us, we set up impromptu meetings with artists in addition to the ones we had scheduled prior to our arrival. It soon became clear that there was not going to be a dearth of artists from which to choose.

Throughout the course of our travels, we interviewed a total of twenty-five artists. They came from many different parts of the country and represented a wide range of ages and levels of professional achievement. We were delighted to find so many artists making exceptional work with natural materials, yet it was a chance meeting with one that challenged the core of our concept.

We were given the name of a young artist who seemed perfect for our program, but there was a hitch. Aiko Miyanaga casts everyday objects—clothing, in particular—not to mention insects, in naphthalene, the aromatic chemical compound found in mothballs. Although it is a manufactured substance, and not a "natural material," naphthalene does evaporate when

exposed to the air—and since Miyanaga's castings disappear due to a natural process, we felt it was necessary to broaden our scope and add this condition to our project.

We returned to Tokyo at the end of our journey, and prepared several boxes to ship back the dozens of portfolios, catalogues, and brochures we gathered along the way. The fourteen-hour flight back to the United States provided plenty of time to narrow down our list, but it would take another month of deliberation to arrive at the ten artists who make up *Force of Nature*.

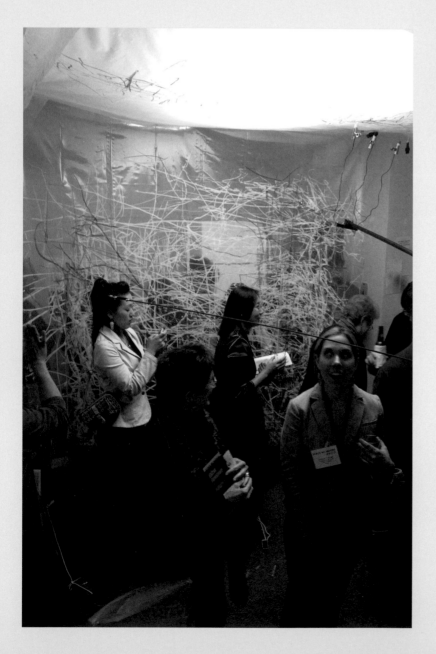

III.

By early 2004, Mark and I were still under the impression that we could each host five artists at our respective institutions— all at the same time! Never mind that neither of our colleges maintains an official program for artists in residence, nor the kind of staff that might facilitate such a massive undertaking. Undeterred, we sent letters to each of the ten selected artists and explained the parameters. They were invited (on a date to be determined) to Davidson College and the Halsey Institute of Contemporary Art at the College of Charleston for a period of six weeks. They were to create temporary, site installations that used readily available natural materials and/or processes. In addition, these new works were to address the link or the disconnect between our modern lives and the natural environment. Simply put, "Are we a part of, or apart from, nature?"

To offer the ideal working situation, we promised to pay for everything, including travel, housing, and materials, as well as a generous honorarium and a per diem allowance. Fueled by a strong belief in our idea and the quality of the selected artists, we scheduled meetings with various funding agencies in both the Carolinas and New York. Every arts-and-culture official who reviewed our proposal was intrigued by the concept and quite taken with all the artists' work; however, we had only marginal success with our initial fundraising efforts. By spring 2005, we realized we needed to change our strategy if we were going to make this project a reality.

IV.

Mark and I felt that expanding the project to include other institutions might prove a prudent way to facilitate it. We invited our colleague Tom Stanley to have a look at the *Force of Nature* proposal. Tom is the director of the Winthrop University Galleries, in South Carolina. Upon reviewing the material, he agreed to host wind artist Rikuo Ueda and paper- and printmaker Yumiko Yamazaki. Winthrop University was the first to join a consortium that eventually would grow to seven institutional partners in the Carolinas.

With Winthrop's encouragement and endorsement, we began to call on other institutions to help share the financial and logistical responsibilities. The positive response was overwhelming, and many were eager to participate in this "category-busting" endeavor.

The additional residency partners chose to host artists whose work and methodologies might benefit from as well as contribute to the core curriculum of their respective programs. The College of Architecture at the University of North Carolina-Charlotte played host to clay-and-wood sculptor Akira Higashi and environmental artist Ayako Aramaki. The Clemson Architecture Center in Charleston worked with the deconstructivist Junko Ishiro. Noriko Ambe, whose stacks of cut paper appear to be vast topographies of imaginary landscapes, worked at the Halsey Institute. The McColl Center for Visual Art, an international artist-in-residency program in Charlotte, hosted naphthalene artist Aiko Miyanaga. Davidson College was host to sound-based sculptor Takasumi Abe and multimedia artist Yuri Shibata. Motoi Yamamoto created his signature salt labyrinths at Davidson College and in Charleston, under the auspices of the Halsey Institute and the Clemson Architecture Center.

Even though the distribution of artists was complete, it took yet another year of copious group emails and planning meetings to finalize all the arrangements in time for the artists' arrival in the fall of 2006. Each institution worked in earnest to apply for additional funding—not only for the expenses related to their individual artists but in support of the overarching costs of program management and promotion. Katherine Borkowski was hired for the year to oversee all the logistical needs, including visa applications, travel, and budgets. Buff

Ross was commissioned to brand *Force of Nature* and design all the printed materials and an interactive web site. Last, photographer Mitchell Kearney was commissioned to document all the artists' projects as they developed over the course of their six-week residencies. More than four years after that conversation at Lake Eden, we were finally ready to initiate our plan.

V.

August 30, 2006, like most late-summer days in Charleston, was hot and muggy. All of the artists were scheduled to arrive that evening in preparation for two days of orientation with the staff and directors of the partner institutions. Throughout the afternoon, we kept a close watch on the weather forecasts: Tropical Storm Ernesto was churning off the coast of South Carolina. Fortunately, Charleston was spared the full impact, but the storm filled the night sky with lightning, which some of the artists compared to a brilliant fireworks display. This was the first trip to the United States for many of them, and the welcome was rather dramatic, if not auspicious.

For the next two days, we gathered for presentations and meetings at the historic Blacklock House, a traditional nineteenth-century building in the heart of historic Charleston. With the aid of our translator, Kana Kobayashi, the artists described in detail their philosophies on art and the methodologies behind their work. They then met individually with representatives of their respective institutions to review project plans and create detailed materials' lists and timelines for production. Even though we took care of a lot of business, plenty of time was devoted to sightseeing and sampling of such Lowcountry fare as shrimp and grits, barbecue, cornbread, and sweet iced tea. It was difficult at times to know if the nuances of the native cuisine agreed with our guests' palates, but spirited conversation and laughter accompanied every meal.

VI.

Our goals now accomplished for the orientation sessions, all the artists, with the exception of Junko Ishiro and Noriko Ambe, departed Charleston en route to their respective

institutions in North and South Carolina. Upon arrival, they were shown to their apartments or, in some cases, checked in with the host families. Later, when taken to their studios, the majority were astonished at the great size. Because of high rents and sheer lack of space in Japan, they often share a four-hundred-square-foot space with as many as six other artists!

Eager to get down to work, the artists unpacked their bags and covered the studio walls with schematic drawings, floor plans, and timelines. To our amazement, every artist brought a camera, a video recorder, and a laptop computer. These enabled them to set up a support network for their fellow *Force of Nature* participants through group emails and sky phones. They diligently used these lines of communication to keep one another informed of their activities by way of digital images and blogs. The sophisticated *Force of Nature* web site featured interactive artist biographies, schedules of events, and a daily update of images of works in progress. The site not only kept the artists, partner institutions, and general public apprised of everyone's progress, it was also a means, remarkable in itself, by which the artists' families and friends in Japan could follow all the activity.

Panel discussions and lectures with artists, project organizers, and scholars were scheduled throughout the six-week period. The halfway point of the residency was marked on September 20 when a large-scale public event was held at the College of Architecture at UNC-Charlotte. Custom-made bamboo tables and banners featuring portraits of all ten artists filled the atrium of the Storrs Architecture Building. More than two hundred and fifty guests dined on sushi and green tea prior to the debut of two very special performances.

A composition for solo piano, *drift . . .*, was commissioned especially by Winthrop University to address the central themes of *Force of Nature*. Inspired by the energy and vision of the artists in residence, composer Ronald Keith Parks wrote the piece for pianist Tomoko Deguchi. This delicate, new work was a sharp contrast to the happening that was about to take place on the lawn adjacent to the architecture building.

During the three weeks leading up to this night, Ayako Aramaki diligently mowed and gathered vast heaps of grass and weeds from various locations of the UNC-Charlotte campus. Within a circular block enclosure on the lawn, she had placed a large, steel Chinese character that represented the word *circle*, which can also be interpreted as *circulation*. Several piles of dried clippings were placed on top of the steel. With torch in hand, Ayako read a prepared statement on cultural identity and rituals. She then set fire to the ring. As the flames grew higher and thick smoke choked the night sky, volunteers from the audience spontaneously assisted Ayako in placing more clippings into the fire. The following day, the ashes were removed to reveal the scorched perimeter of the Chinese character, its spirit dramatically burned into the landscape.

During the remaining three weeks, installations were completed, and openings at the partner institutions were staggered over the entire second week of October. Interviews and reports aired on National Public Radio, and articles were published nationwide in newspapers, magazines, and arts journals. As many institutions set new attendance records, they also established connections with new and diverse audiences.

In mid-October, the artists returned to their native Japan. The departure was bittersweet, but they left with a newly established network of peers who will provide a source of mutual support over the coming years. They have already begun collaborating on grants that will enable them to invite Mark and me to return to Japan for a series of lectures and symposia about the logistical and conceptual success of the project. In addition, a capstone exhibition at the Sumter County Gallery of Art, featuring documentary photographs and examples of remaining artwork that celebrate the many components of *Force of Nature*, will serve, along with this catalogue, as a historical record.

Countless students, faculty, and staff of the host institutions, as well as members of the surrounding communities, were unexpectedly enriched by the presence of our extraordinary guests, these sensitive individuals whose kindness, generosity, and insight illuminated our often-tenuous relationship with the natural environment. Through their highly focused and distinctive creative endeavors, every artist has provided a point of reference with which we may better understand our physical and spiritual surroundings. The imprint that each has made is deep and lasting.

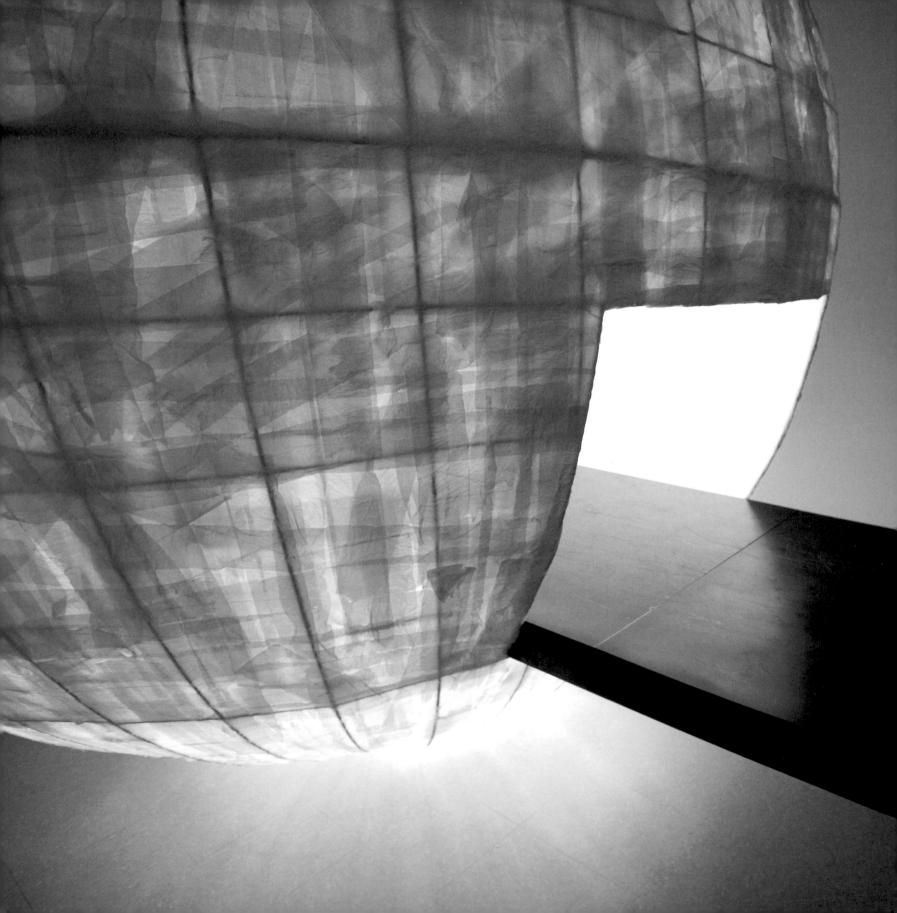

AXIS MUNDI
mark sloan

Just after dusk one evening, shortly after our arrival in Japan in November 2003, Brad Thomas and I were visiting a temple in Kyoto with our friend and guide Noriko Fuku. As a full moon was beginning to rise over the temple wall, we commented to one of the monks that the scene was quite beautiful. On such nights, he said, the monks gather in the garden to celebrate the full moon with a sake toast. First, they fill their sake cups to overflowing. Then, they hold the cup at just the right angle so the reflection of the full moon can be seen on the surface of the clear liquid. Last, they sip the moon's reflection—to celebrate and share in its power.

This reverence for a human's place amid nature and its rhythms is certainly not unique to Japan, but a compelling case can be made that the Japanese have refined these encounters with a poetic fervor. The traditional arts of ikebana, kare-sansui style of symbolic gardening, tea ceremony (which embodies the ceramic arts), and even the origins of sumo wrestling all emerged from an attempt to apprehend nature's secrets. That these Japanese forms have endured for hundreds of years is a quiet testament to the success of Japanese artists who have made this dialogue relevant to the contemporary citizen.

The quest for an understanding of our place in the cosmos is as old as civilization itself. Every culture has invented some form of mythology or religion based upon this concept, and their artists or shamans have often been called upon to depict this relationship in terms that one can readily grasp. In today's world, artists are still grappling with these eternal questions, primarily in more cerebral ways. Earth and environmental art emerged in the 1960s and 1970s as a radical departure from the concept of representing

nature through a painting, or other work, to artists actually intervening in nature itself. Such artists as Michael Heizer, Nancy Holt, Richard Long, and Robert Smithson, among many others, took their work out into nature and began a movement that has captured the enthusiasm of many adherents in the international art world today.

This impulse to intervene in nature seems to be particularly ardent in postwar Japan. In 1994, the landmark exhibition *Japanese Art after 1945: Scream Against the Sky* examined the expressions and developments of Japan's avant-garde. With more than one hundred artists, this survey exhibition and accompanying book, organized by the Guggenheim Museum in New York, and the San Francisco Museum of Modern Art, traced the lineages of several different artistic and collaborative movements, including Gutai, Hi Red Center, the Experimental Workshop, and Mono-ha. In the past two decades, Japanese artists have been featured in several international art exhibitions exploring the fertile terrain of art and nature. The traveling exhibition *A Primal Spirit: Ten Contemporary Japanese Sculptors*, organized by the Los Angeles County Museum of Art, drew attention to the aesthetic link between nature and art in Japan, and the productive effect this relationship has on contemporary Japanese artists.

The Gutai group and Mono-ha were two of the most significant artistic movements in postwar Japan. The Gutai group, formed in 1954, in Osaka, is often mistakenly commingled with abstract expressionism in the West; however, Gutai artists were revolting against art-world conventions, including abstract painting. In a quote from the *Gutai Manifesto*, published in 1956, one of the founders, Jiro Yoshihara, wrote: "We have decided to pursue the possibilities of pure and creative activity with great energy. We tried to combine human creative ability with the characteristics of the material in order to concretize the abstract space." Gutai artists engaged in actions, sometimes involving performance, sound, spoken word, and other less traditional forms of expression. Their activities were occurring shortly after John Cage's first happening at Black Mountain College, in 1952, and are often cited as anticipating performance art and conceptual art. The Gutai group dissolved in 1972 after the death of Yoshihara, but its legacy has left an indelible mark on the international art scene.

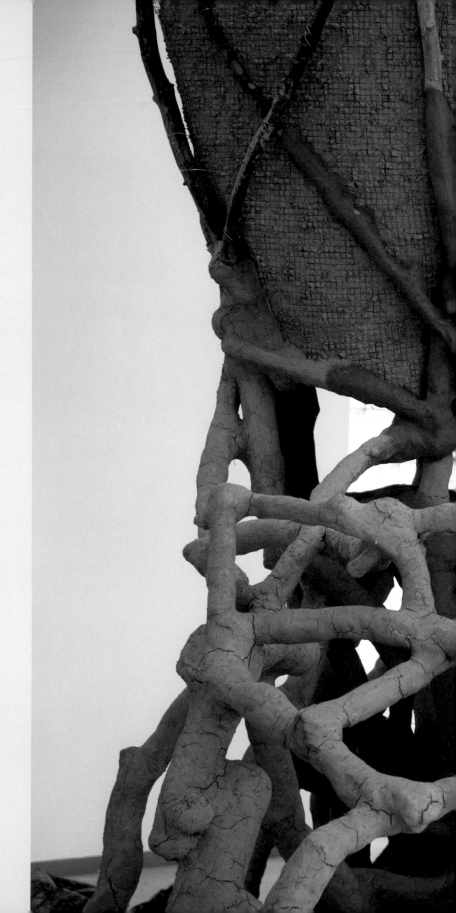

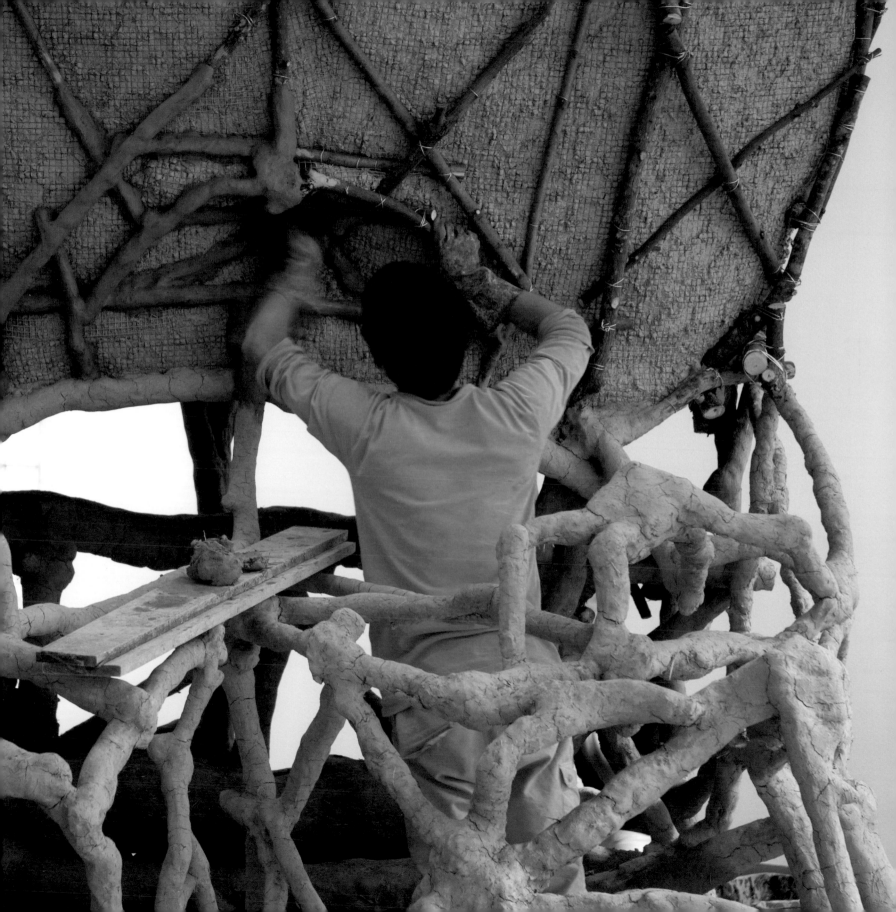

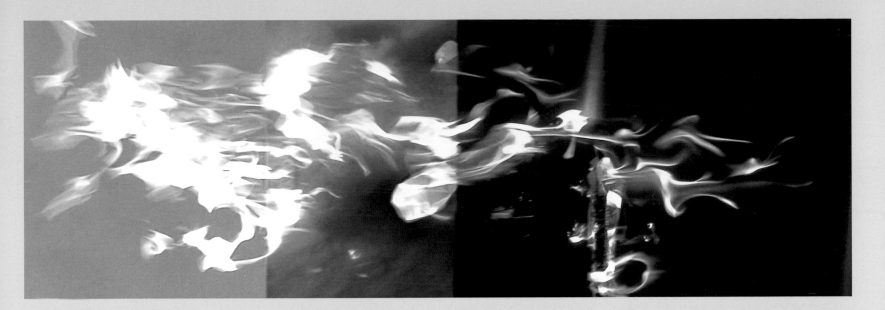

Mono-ha emerged in Tokyo in the late 1960s, and was more a loose affiliation than a movement per se. Since many Mono-ha artists used found or natural materials in their artwork, and because they often created ephemeral installations, the impact was difficult to measure. Although far less mythologized than their Gutai predecessors, many Mono-ha artists have had a profound effect on the shape of contemporary art in Japan. Kishio Suga was among the key artists of Mono-ha. One of his best-known works was installed in a propped-open window of a Kyoto museum in 1970, and was entitled *Infinity Condition*. The materials were listed on the wall label: "square wood beams, structure of building, outdoor scenery." Although the anticommercial aspects of their work offered a critique of modernism and its obsession with objects, Mono-ha is now often linked indirectly to such modernist subgroups as *arte povera* and minimalism. Like Gutai, Mono-ha has had a lasting and profound effect.

The *Force of Nature* artists are direct descendants of this artistic lineage, although they are not limited by it. Certain themes and concepts echoed among the various artists' projects. Circularity was a recurring motif. Whether we speak of the cycle of birth, life, death, decay, and rebirth, or the circulation of blood or clouds, the artists actively seemed to invoke this metaphor throughout their various projects. There was also a particular focus on the materiality of nature itself, as evidenced most directly in Yuri Shibata's *Material Works*, Rikuo Ueda's *Wind Drawings*, and Yumiko Yamazaki's buried copper plates. Each artist was able to create a work that engages the complex and often confounding relationship between humans and the natural world.

Each artist made intelligent choices about the methods of presentation and documentation of their final installations within the exhibition spaces provided. Often, they offered sly critiques of the tyranny of the white cube. Aiko Miyanaga's *Seven Stories* were spread throughout the McColl Center; viewers embarked on what amounted to a scavenger hunt to discover all of her pieces in their sometimes offbeat locations. Similarly, Noriko Ambe used a ripsaw to cut a gash in the Halsey Institute gallery wall so that her tree slice could connect with her cut-paper works on the floor. Takasumi Abe's "cloud sphere" was so snuggly inserted into the Smith Gallery at Davidson that audience members likened it to a ship in a bottle, wondering how did it fit through the doorway (in fact, it was assembled in pieces on-site).

The sheer variety of materials and approaches evidenced in *Force of Nature* is staggering. The conceptual basis for the show was explored in ten different yet complementary ways. As curators, it is our hope that this exhibition will offer inspiration for future generations of artists, just as these artists represent a distillation of all they have encountered in their practice. Our goal was to create a set of optimal conditions in which these artists could work—in which anything could happen. Many things did.

INSTITUTIONAL PARTNERS:

Halsey Institute of Contemporary Art at the College of Charleston

Van Every/Smith Galleries at Davidson College

College of Architecture at UNC-Charlotte

Clemson Architecture Center in Charleston

Winthrop University Galleries

Sumter County Gallery of Art

McColl Center for Visual Art

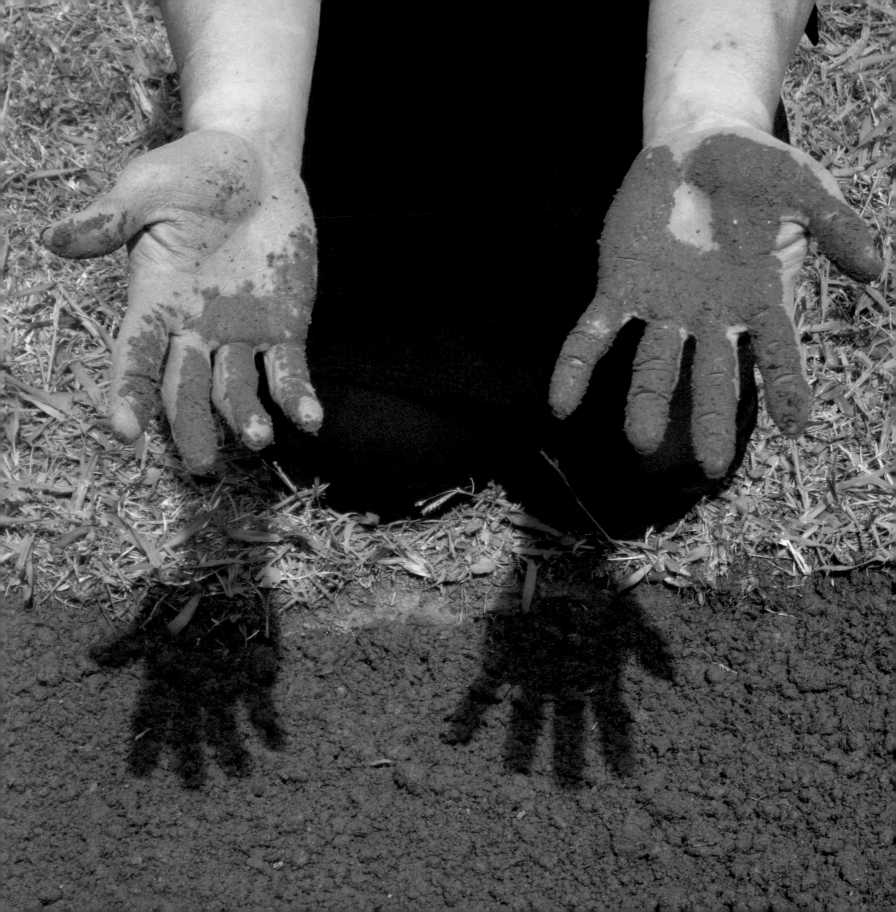

 takasumi abe

 noriko ambe

 ayako aramaki

 akira higashi

 junko ishiro

 aiko miyanaga

 yuri shibata

 rikuo ueda

 motoi yamamoto

 yumiko yamazaki

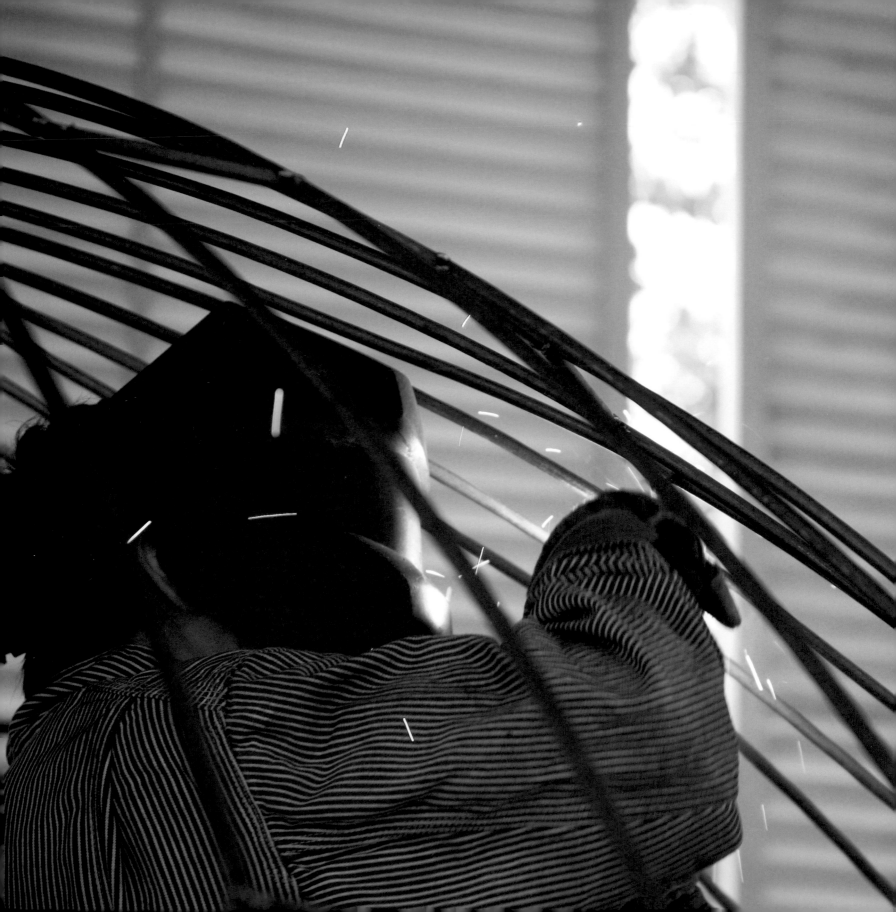

Takasumi Abe
Van Every/Smith Galleries at Davidson College

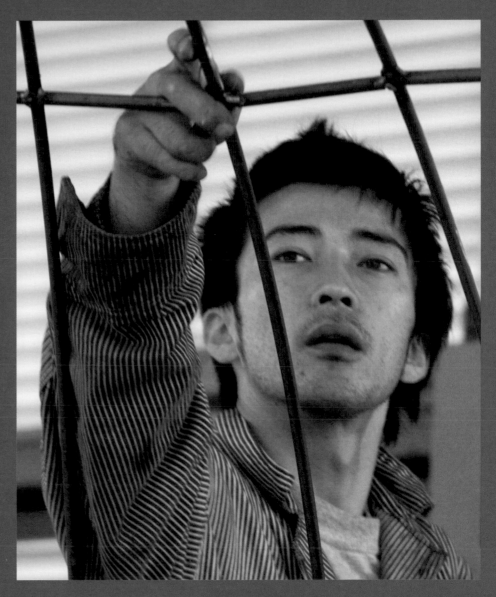

Born in Oita Prefecture, Japan, in 1976, Takasumi Abe received his B.A. in sculpture from Kyushu Sangyo University, Fukuoka, in 1999, and his M.F.A. in sculpture from Kyushu Sangyo University in 2001. He founded his own artist-in-residency program in Fukuoka, art space tetra, that celebrates adventurous explorations in art and music. His works have been exhibited in Japan at Sango Soko, Fukuoka; art space tetra, Fukuoka; Fukuoka Prefectural Museum of Art; Kitakyusyu Municipal Museum of Art; and Tokyo Metropolitan Art Museum. Takasumi Abe lives and works in Fukuoka.

Circulate

Sculptor and sound artist Takasumi Abe uses sounds that occur both in nature and inside the human body to comment on the inherent link between inner and outer worlds: circulation. Several years ago, intrigued with the seemingly inaudible sound of clouds, he constructed a large receiver and transmitter from welded-steel rods and tissue that attempted to amplify them. The ambient document that was recorded has prompted him to continue this investigation with a new approach.

For his installation at Davidson College, Abe created one thousand graphite drawings of clouds (figs. 5, 6, 7). First, building up the surface with graphite, then erasing layers to varying degrees, he created a visual reference to complement the experience of hearing the clouds in his installation (figs. 8, 12, 13). He then created a walk-in sphere that contained the sounds of clouds he recorded high above Lake Norman. Projected on the wall directly across from the "cloud sphere" was a digital animation of the cloud drawings (fig. 8).

Abe rigged a special low-tech solution to record the sounds of clouds at Lake Norman, pointing out that any other man-made device besides balloons makes too much noise on its own to be able to get an accurate recording (fig. 4). Using kite string, an iPod with a microphone, and a borrowed boat, the artist and a small crew, including David Boraks, contributor to Charlotte public radio station WFAE-FM, and Gavin Weber, launched twelve helium-filled garbage bags more than one thousand feet into a cloud-dotted sky (fig. 3). The resulting recording provides an authentic experience of what might be called "cloud music." Since clouds hover above the earth, they are a visible representation of the concept of circulation. They contain moisture that has evaporated from one location on the surface of the earth only to be deposited upon another, starting the cycle again.

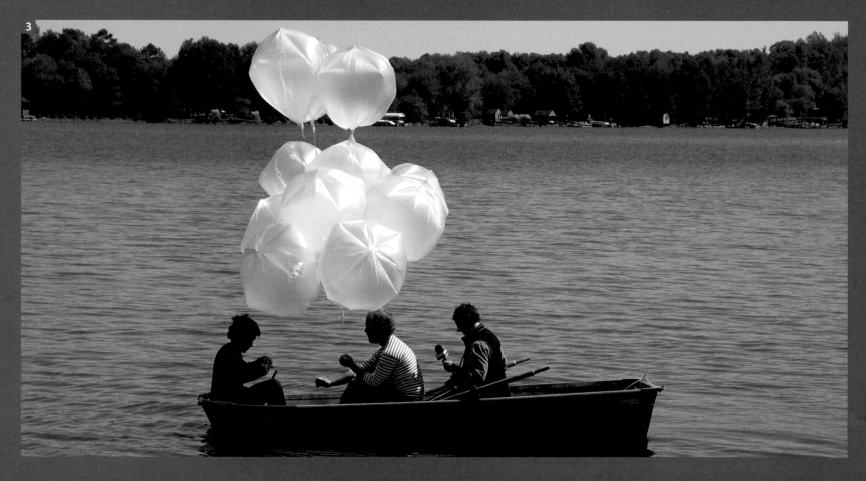
3

4

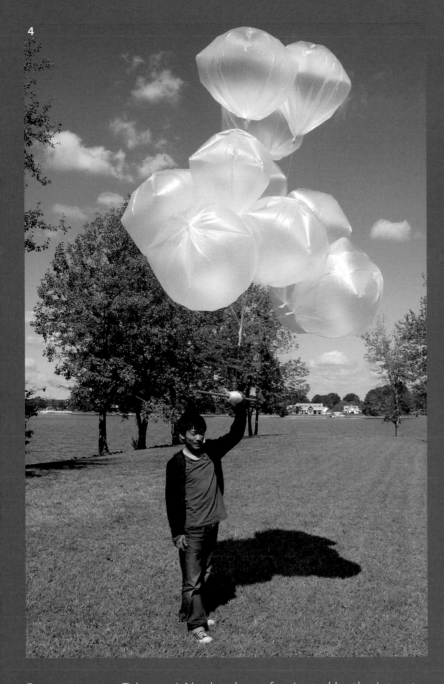

gallery space. Thus, the inside of the human body becomes, on a global scale, a metaphor for his concerns.

According to the artist, there is a special temple in Kyoto where the sound of clapping hands might be taken for thunder. This phenomenon is, no doubt, because of the special acoustic environment created by the architectural properties of the temple. During the process of creating this installation, Abe stated that he wished his sphere to have some of those same "magical" qualities. He only knew that he trusted in the process of his art, and that he would apply his attention and action to this goal. Many visitors to the cloud sphere remarked that the sounds inside were reminiscent of the sound of human breathing—a comment that Abe greatly appreciated.

5

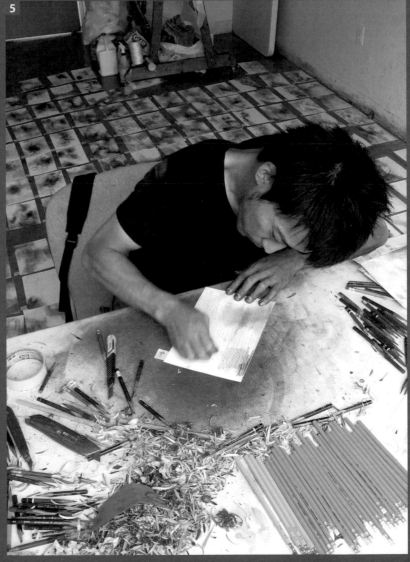

For many years, Takasumi Abe has been fascinated by the intractable questions posed by nature. Of particular interest to him is the concept of the mass extinction of a species. He wonders what it is that allows some species to flourish, others to maintain their population, still others to go extinct. It is the hidden mechanisms of nature that engage Abe's restless mind. Yet, all of these interests center on the idea of circulation. He has created installations wherein gallery viewers can listen to their own hearts and lungs (through a stethoscope), and have the sounds amplified throughout a

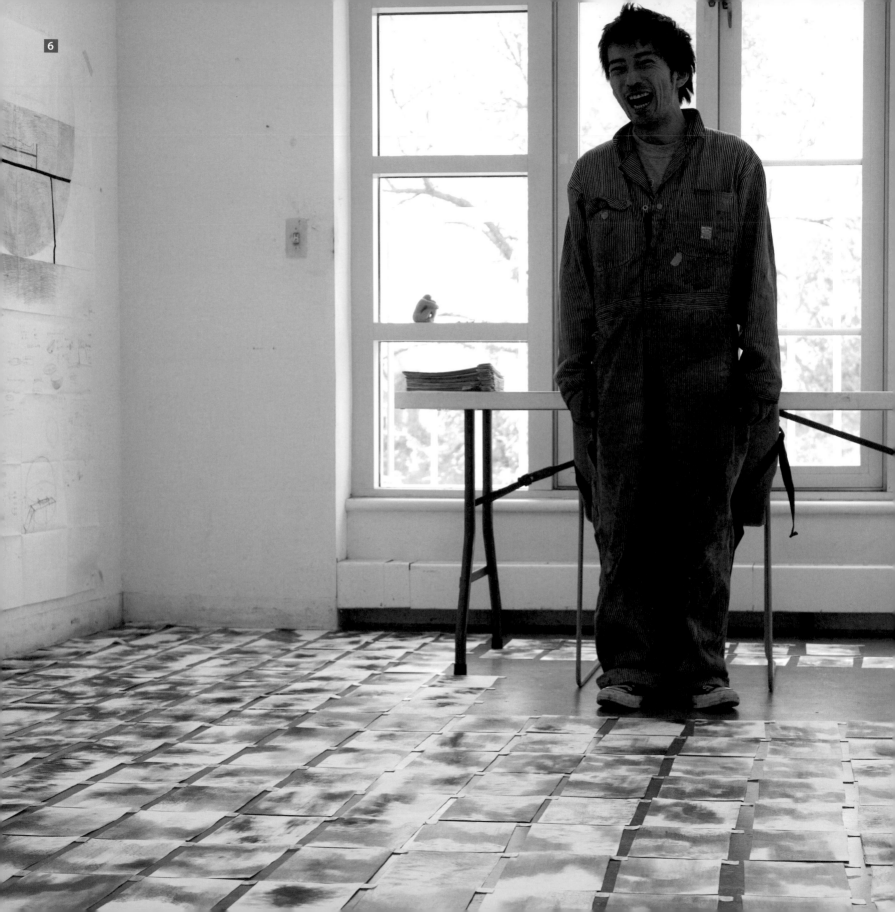

7

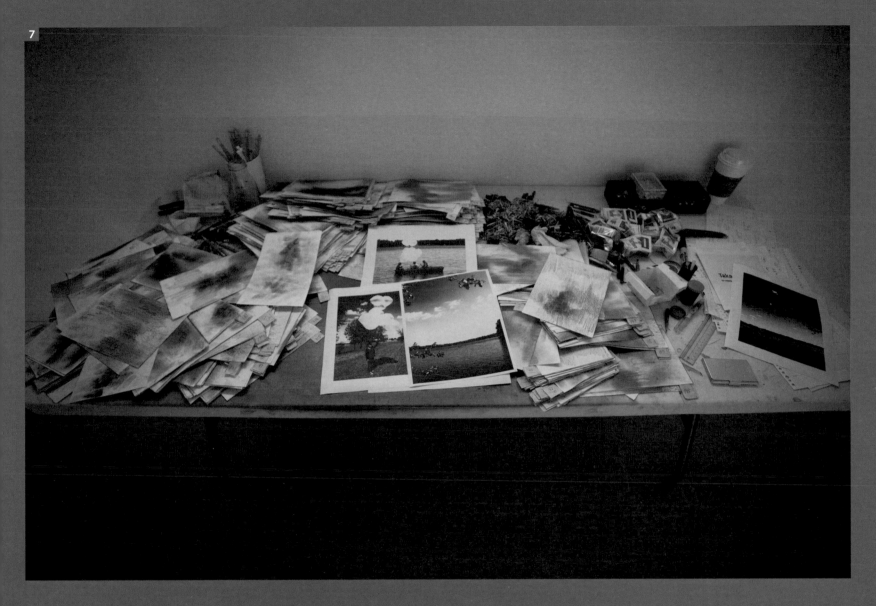

Figs. 6, 7, 8: Each graphite drawing of clouds considers the presence and absence of the clouds. The empty areas imply air or space, two things that are rarely considered, or implied, in visual art because of their invisibility. This repetitious exercise of drawing clouds brings together many senses, such as seeing, feeling, and hearing, in addition to memory.

Figs. 9, 10, 11: A performance piece accompanied the installation on opening night, introducing yet another layer to the overall experience. Using toilet paper and tiny ink-filled capsules, Abe alternated rolling toilet paper, throwing the capsules on the paper, rolling another layer of paper, and, last, walking on the paper and ink pellets. The stain of the ink bled through the many layers of tissue. (Following pages)

Additional image credits: Figs. 3, 4, 5 by Brad Thomas and fig. 13 by Michelle Van Parys.

8

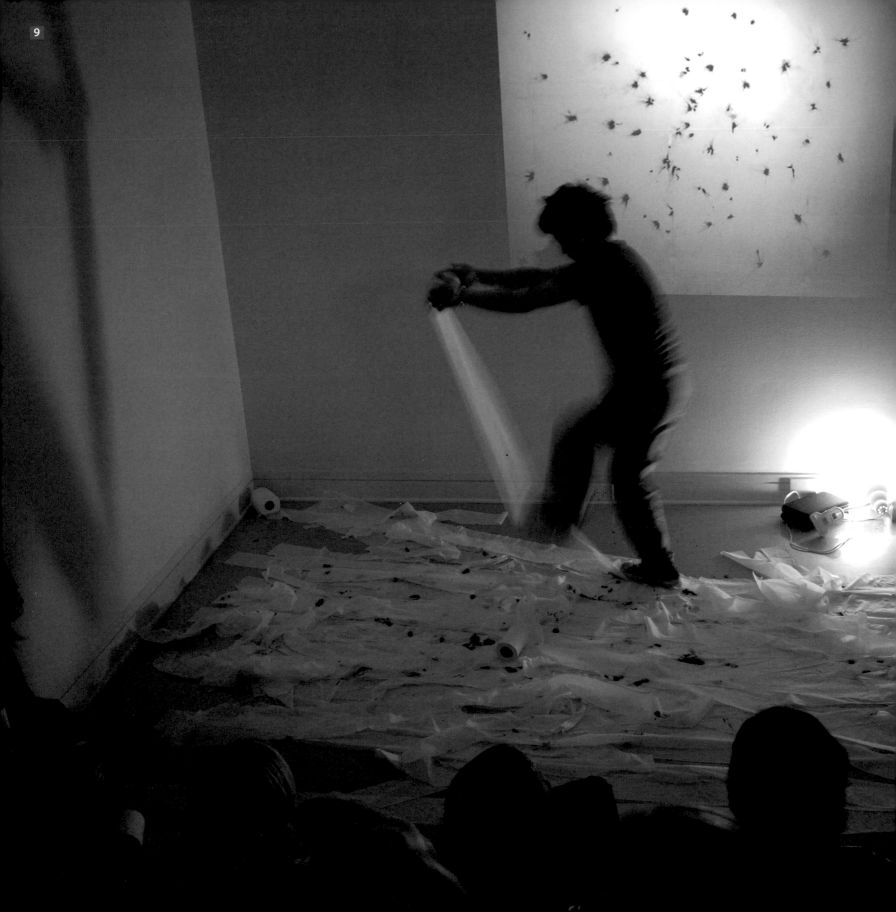

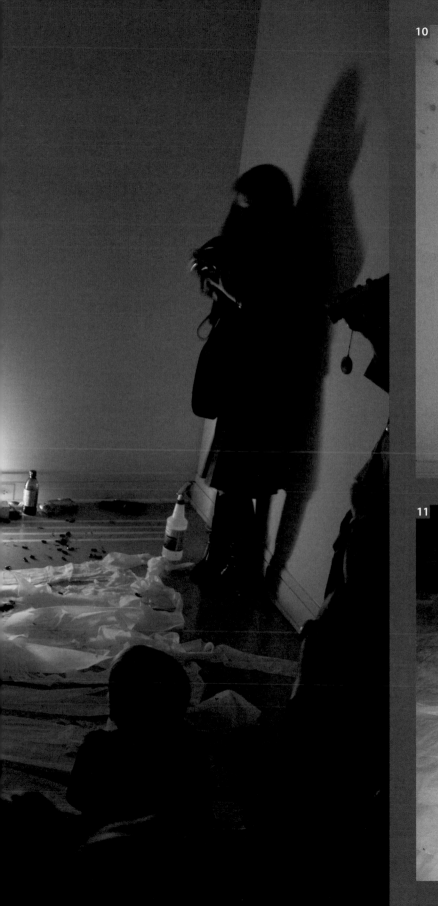
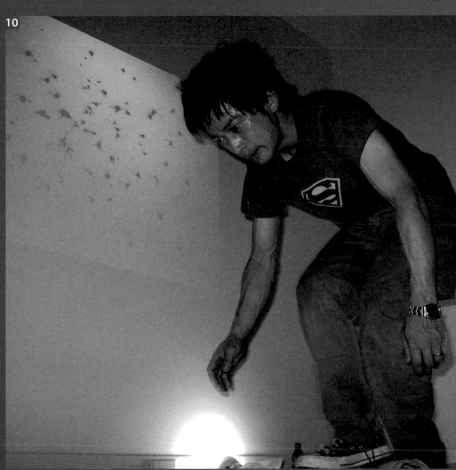
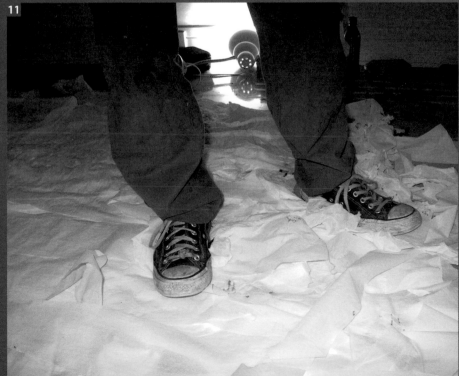

Figs. 12, 13: The "cloud sphere" was constructed of a metal armature wrapped in toilet paper that was stiffened with diluted Elmer's Glue. To gain entry, visitors had to crawl into the sphere, going from familiar surroundings into a stark white space filled only with the unfamiliar sounds of clouds.

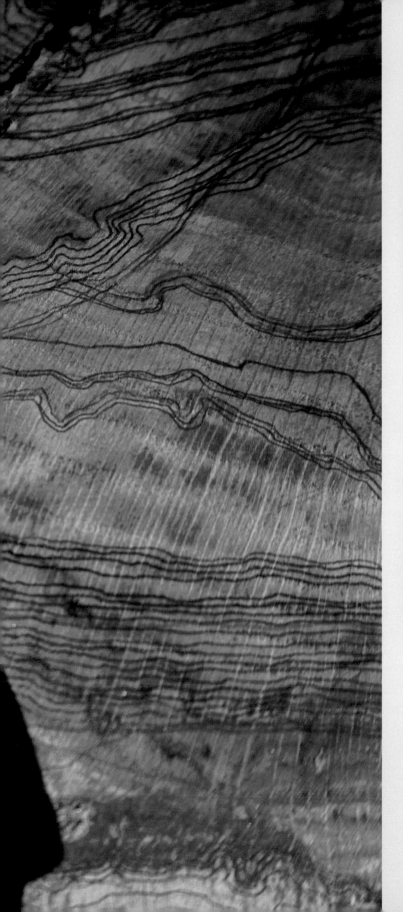

Noriko Ambe
Halsey Institute of Contemporary Art

Born in Saitama, Japan, in 1967, Noriko Ambe received her B.F.A. in oil painting from Musashino Art University, Tokyo, in 1990. She has had numerous exhibitions and residencies internationally. The latter include: Vermont Studio Center; Snug Harbor Cultural Center; Lower Manhattan Cultural Council; Art Omi; and Studio Caminitzer in Lucca, Italy. Her work is in the permanent collections of the Whitney Museum of American Art, New York; the Francis Greenburger Collection, New York; and the Urawa Museum in Japan. Her works have been exhibited at the Museum of Modern Art, Tokyo; Pierogi Gallery, Brooklyn, New York; Palm Beach Institute of Contemporary Art, Lake Worth, Florida; Tyler School of Art, Philadelphia, Pennsylvania; and the Drawing Center in New York. Noriko Ambe lives and works in New York City.

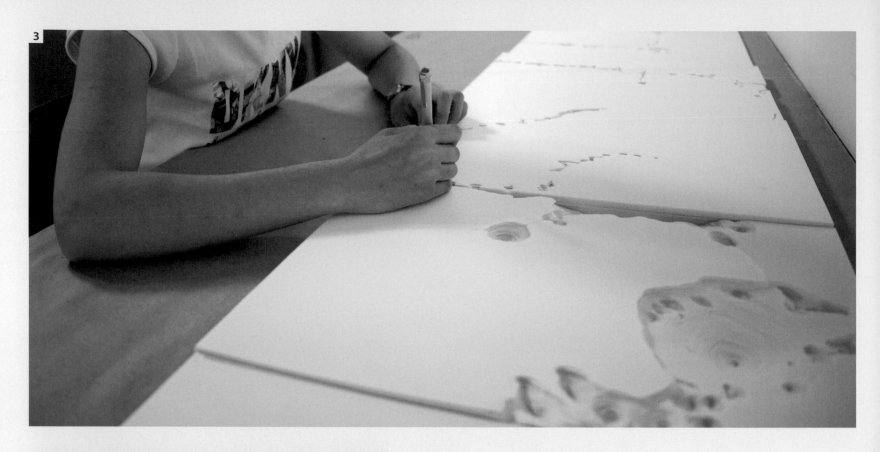

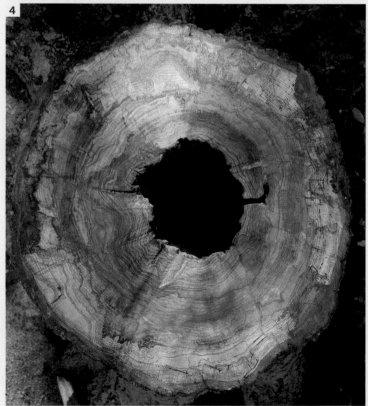

Dialogue with a Tree

Best known for her works involving the meticulous cutting and layering of hundreds of pieces of white paper, Noriko Ambe creates sculptural landscapes that evoke a subtle feeling of loss and detachment (fig. 3). For *Force of Nature*, Ambe explored this concept in an installation using both paper works and drawing on the annual rings of a tree in the forest (figs. 1, 2, 4). A photograph of a tree trunk on which she had drawn was projected in the gallery, where the artist extended her drawing onto the gallery wall itself (figs. 5, 6). Through this layering of imagery, she created an interaction between past and present. The rings of a tree are a visible marker of the passage of time. Within this installation, the pace of nature is amplified by the artist's interventions highlighting the actions of a single human life. The cut-paper works were integrated into the installation, echoing the cracks and crevices of the tree. Ambe also went so far as to violate the gallery's walls by cutting into them and drawing on them in an effort to demonstrate the interconnectedness of all things, including the ubiquitous "white cube" in which her works are often seen.

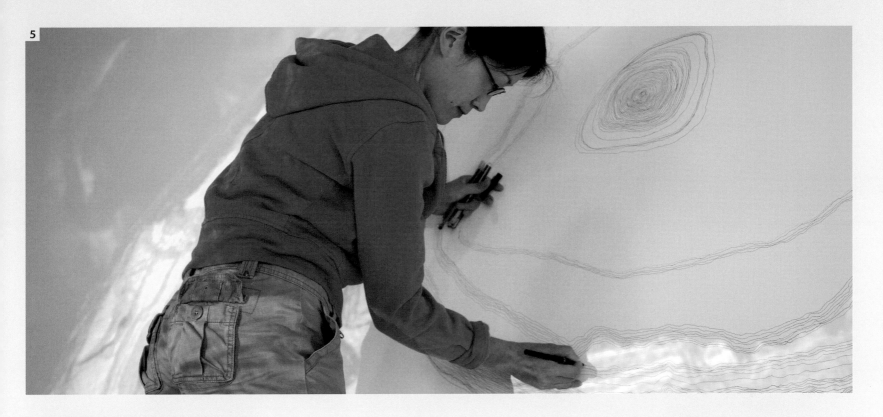

5

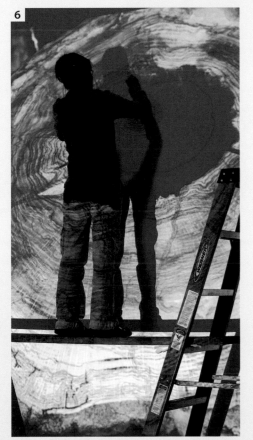

6

For Ambe, the accumulation of her drawings or cuttings represents a marking of time. Time is a central element in her oeuvre, now spanning six years of a self-defined ten-year commitment to explore these "linear actions." The artist sees nature as her teacher. In her words, "Humans are the microcosmos." All life is contained within us and extends well beyond us. The actions she performs are all linear, and human, yet everything is informed by what surrounds us. In tracing the preset patterns of the annual rings of a tree, she is collaborating with nature on its own terms. Extending these drawings to incorporate the gallery wall and to engulf a space offers a humble, human dimension to the "dialogue."

Noriko Ambe sees her work as a continuation of her worldview. In the cut-paper works, she describes the uncut sheet as a metaphor for the universe. Once she begins cutting layer after layer, she is defining her presence and her time on the planet. In that sense, she is cutting herself out of the universe to describe more accurately her distinctiveness within it. She often refers to the cut-out (or positive) elements of her work as representations of her own "spirit" (fig. 14). The resulting absence is a visible reminder of the place of humans within the universe.

Art historians may be tempted to classify Ambe's work as having neominimalist tendencies, but, in fact, she is attempting to provide a compelling case for process being as important as product. By using Yupo, synthetic white paper, and natural elements, she is aligning her own artistic practice with the habitual traces of nature (fig. 15). She is less interested in the finished piece than in the process of attending to the nuances of nature as they inform her hand and mind.

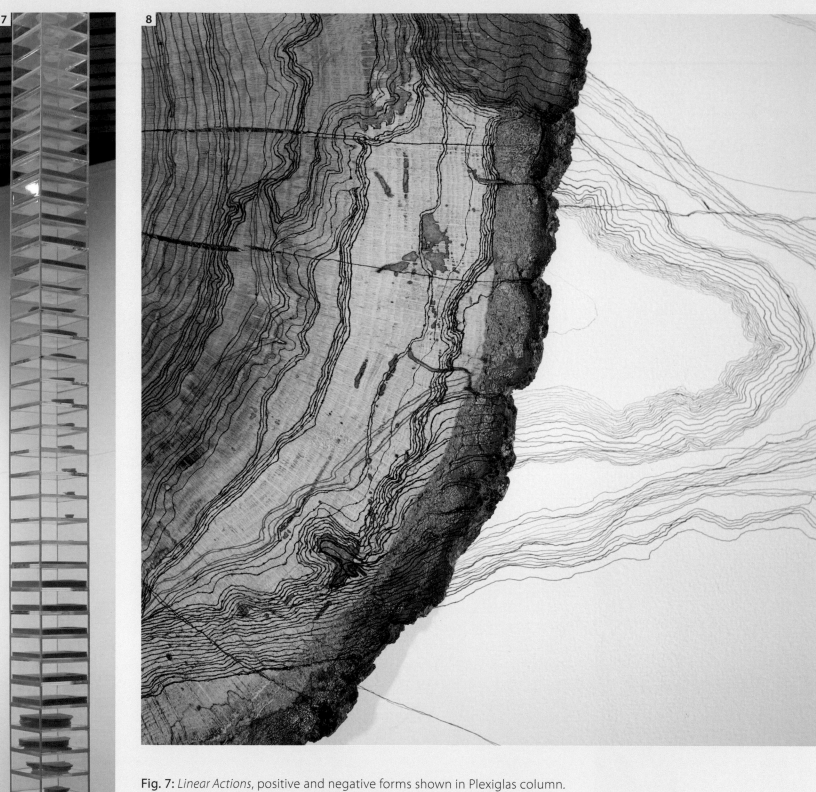

Fig. 7: *Linear Actions*, positive and negative forms shown in Plexiglas column.
Fig. 8: Detail of drawn tree rings on the tree and extended onto the wall.
Fig. 9: Taking a book about a Charleston blacksmith, Philip Simmons, Ambe cut into the book, marking her time in Charleston. The book becomes a metaphor for a specific time and place.

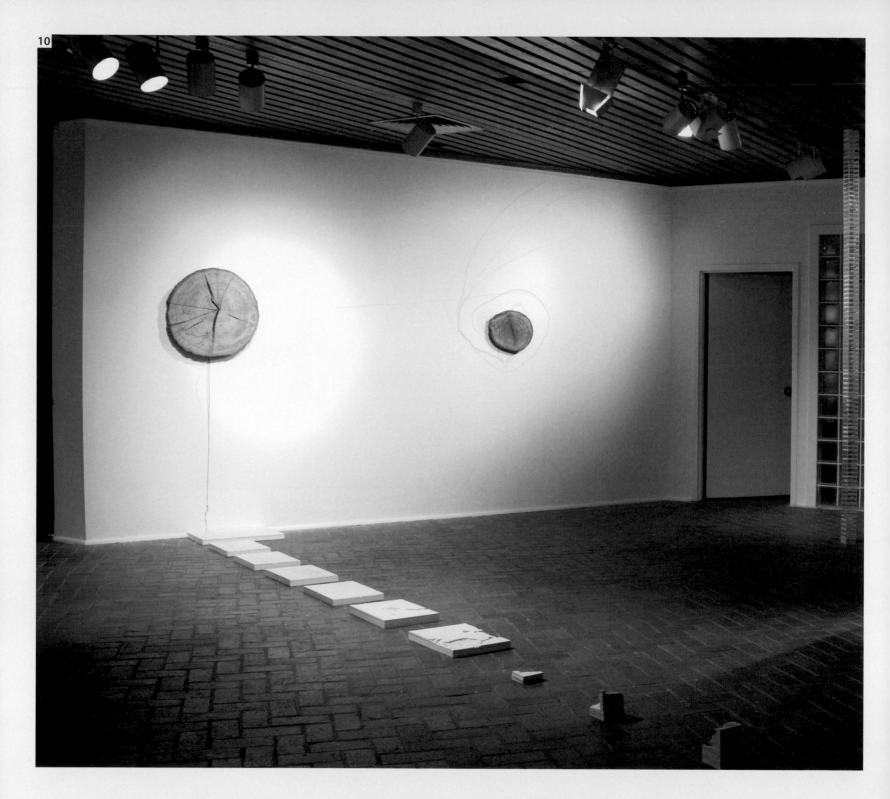

Fig. 10: Installation view of the gallery. Ambe extended a crack from a section of the tree onto the wall and continued to the floor. The crack then connected the tree with the cut-paper work on the floor, both being variations of a similar medium.

Figs. 11, 12, 13: From the projected tree, the artist extended the tree rings onto the gallery wall. The dialogue with a tree was fully realized. (Following pages)
Additional image credit: Fig. 14 by Buff Ross.

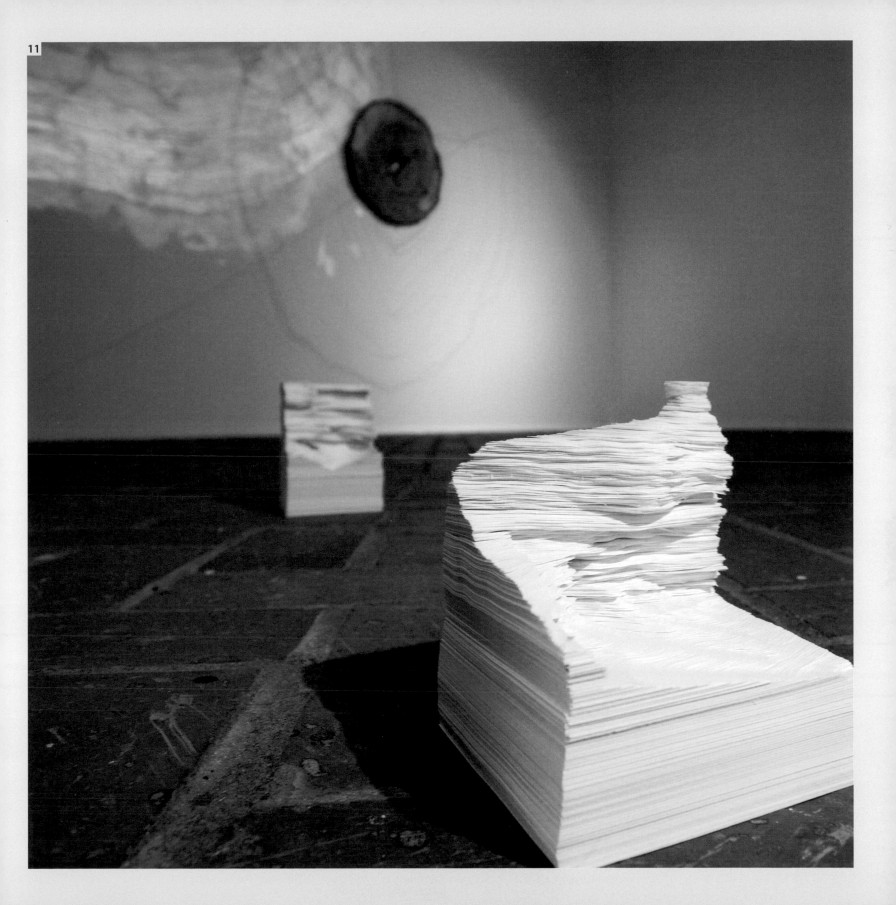

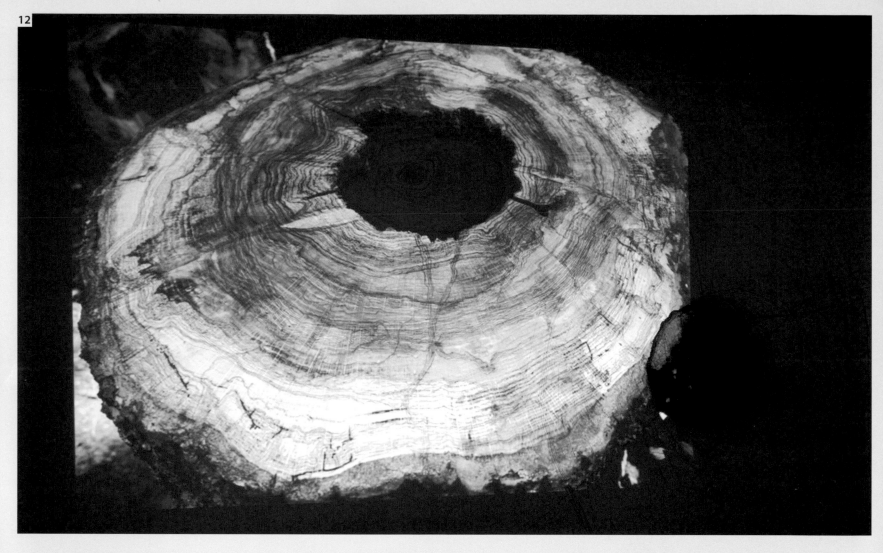

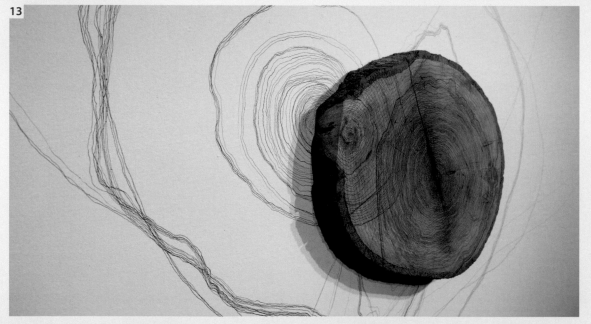

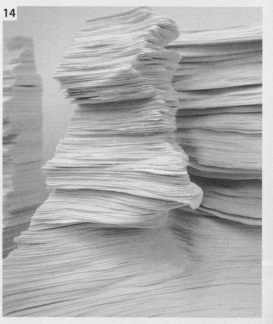

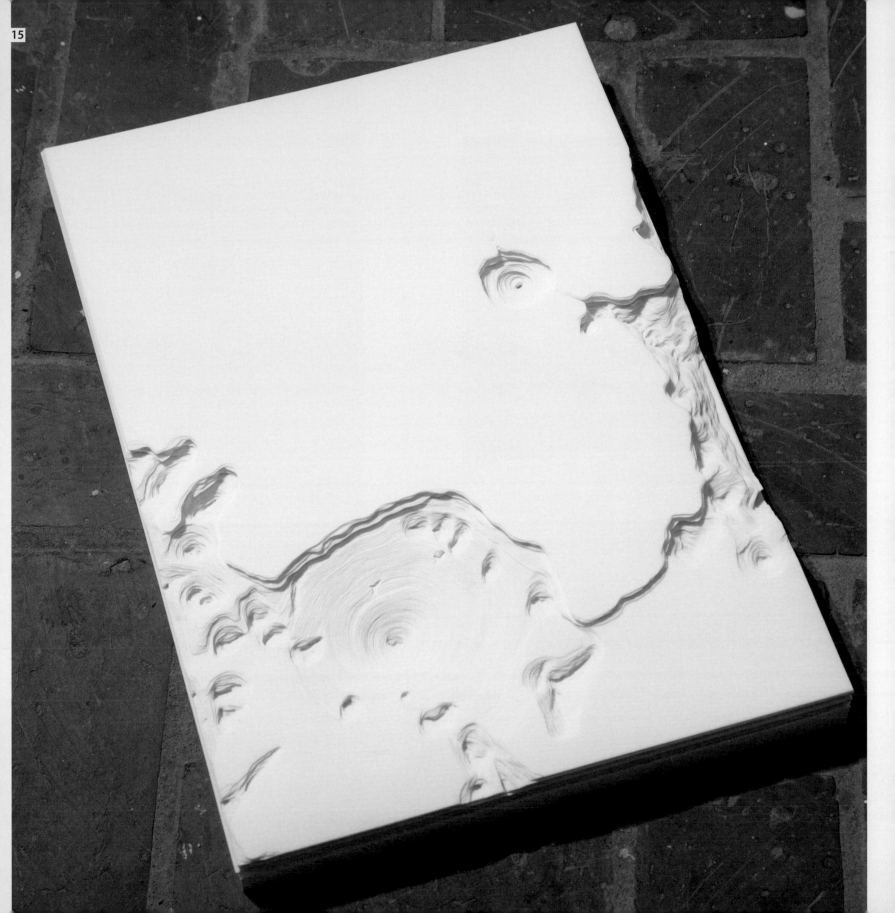

Ayako Aramaki
College of Architecture at
the University of North Carolina-Charlotte

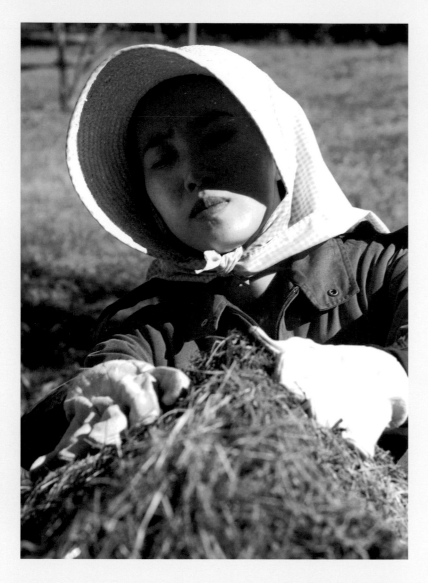

Born in Suita City, Osaka, Japan, in 1973, Ayako Aramaki received her M.F.A. in sculpture from Kyoto City University of Arts in 2000. She has worked on numerous exhibitions and projects in Japan. Exhibitions include: The Third Gallery Aya, Osaka; Osaka Contemporary Art Center; and O Gallery Eyes, Osaka. She has constructed Compost Houses in Osaka, Shiga, and Hyogo. At present, she lives and works in Shiga.

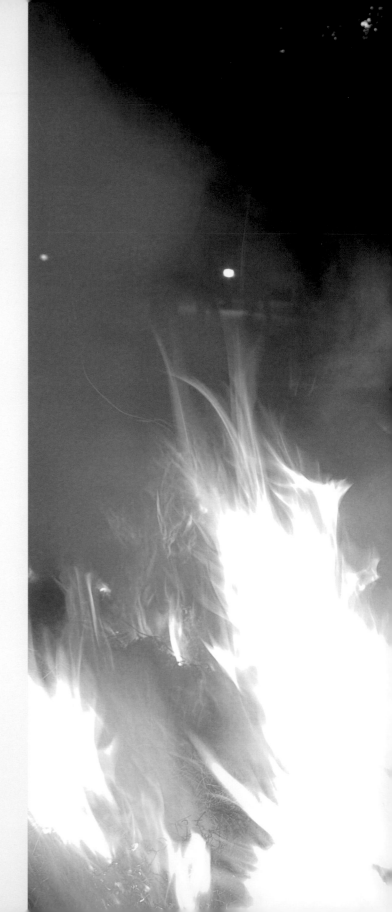

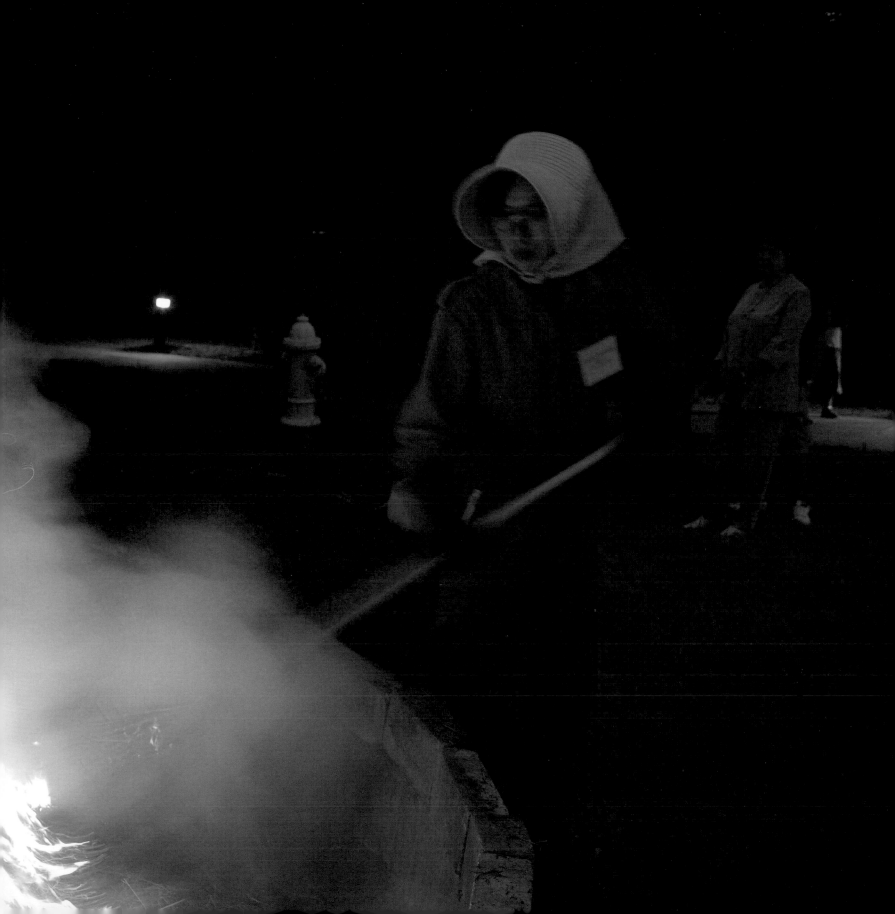

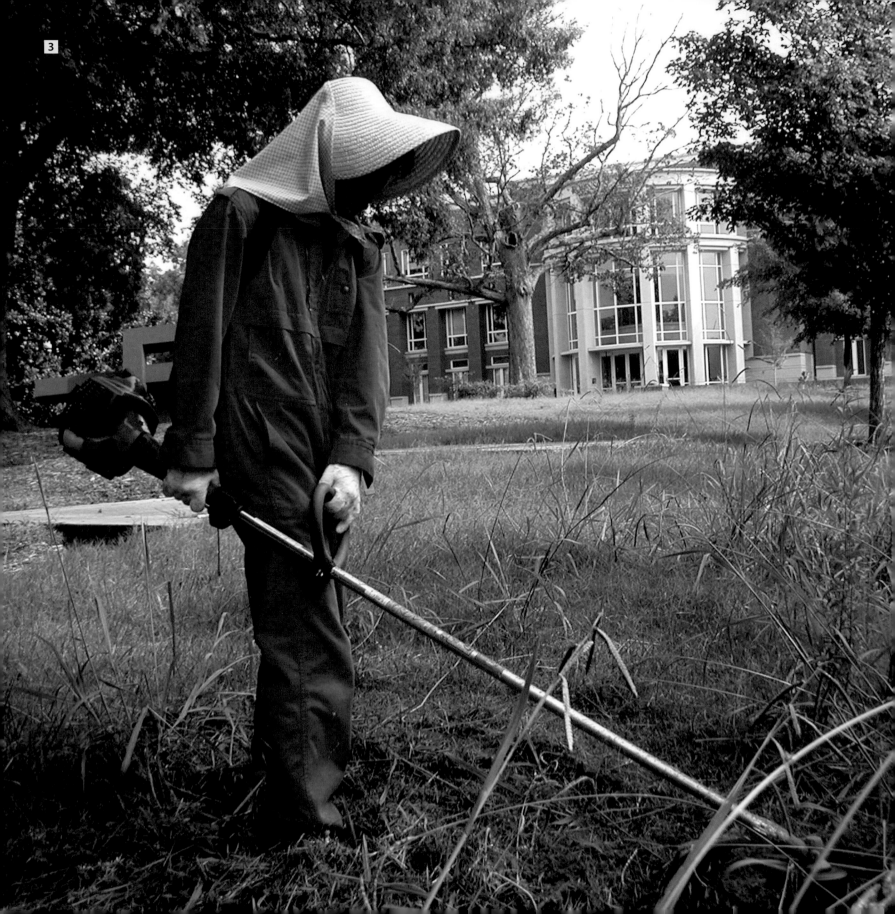

Circulation
and
Compost Suburb

Ayako Aramaki grew up in a suburban environment, yet she longs for the simplistic attraction of wilderness and countryside. In suburbia, she wonders where her roots are. She admires the centuries-old processes that farmers have used to cultivate and preserve the land. The agricultural cycle of growth, death, compost, and renewal holds a special fascination for her. As a way of merging these two disparate worlds, she has produced two interrelated projects at the University of North Carolina-Charlotte.

Prior to her visit, Aramaki asked the university to leave large, grassy portions of their campus unmowed for many months so that she would have tall grass and weeds to work with for her projects when she arrived in early September (fig. 3). Her first work, *Circulation*, was created using steel plates cut into the shape of the Chinese ideogram for "circulation" or "recycle," to be laid on the ground (fig. 6). This symbol, dating back to ancient

Buddhist philosophy, is indicative of the equality among all things. The artist then created a giant heap of harvested, dried grass on top of this ideogram and, like an artist-shaman, set it on fire at a public event (figs. 2, 8, 9, 10, 11). The resulting bonfire consumed the dried grass, leaving behind a kind of tattoo on the landscape in the form of this Chinese ideogram. Grass was the first thing to grow back on the area covered by the steel plates, thus emphasizing the circulation metaphor.

For the second project, *Compost Suburb*, the artist created houselike structures (figs. 4, 5), again using dried grass she had harvested with a gas-powered weed trimmer (fig. 3). These houses were spread around the campus, and were occasionally clustered on a cul-de-sac, as in suburbia. The forms that dotted the freshly cleared landscape questioned the concept of development and man's insistence on interfering with the

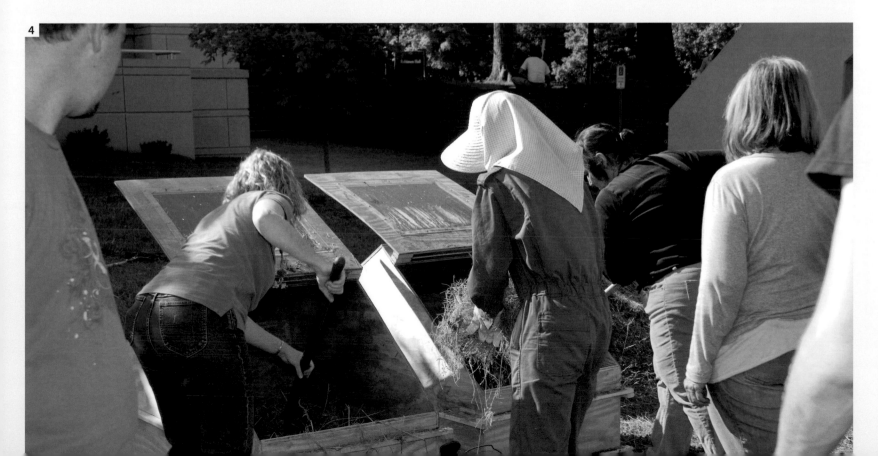

4

natural order (fig. 7). While on the campus, Aramaki wore a bright red jumpsuit with a traditional farmer's hat, and was frequently seen slinging her weed trimmer against the waist-high grasses. She wore this bright suit to attract attention to her concept of working the land. That she may have looked like an alien was intentional: She was making a point about our relentless pursuit of the control of nature.

For Aramaki, it is not enough to accept suburban sprawl as a natural consequence of the growth of cities. Her art is a poetic intervention into the cycle of land use, while paying homage to humble farmers and their wisdom of working with nature.

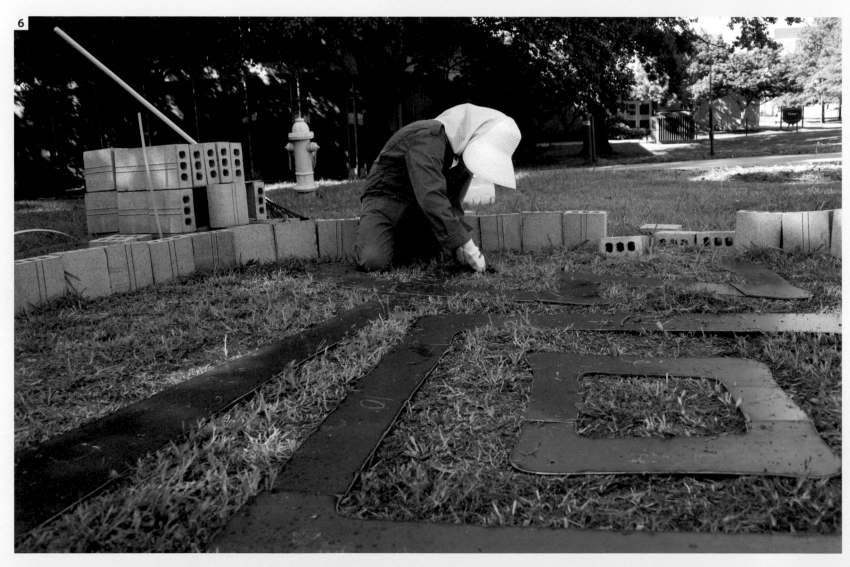

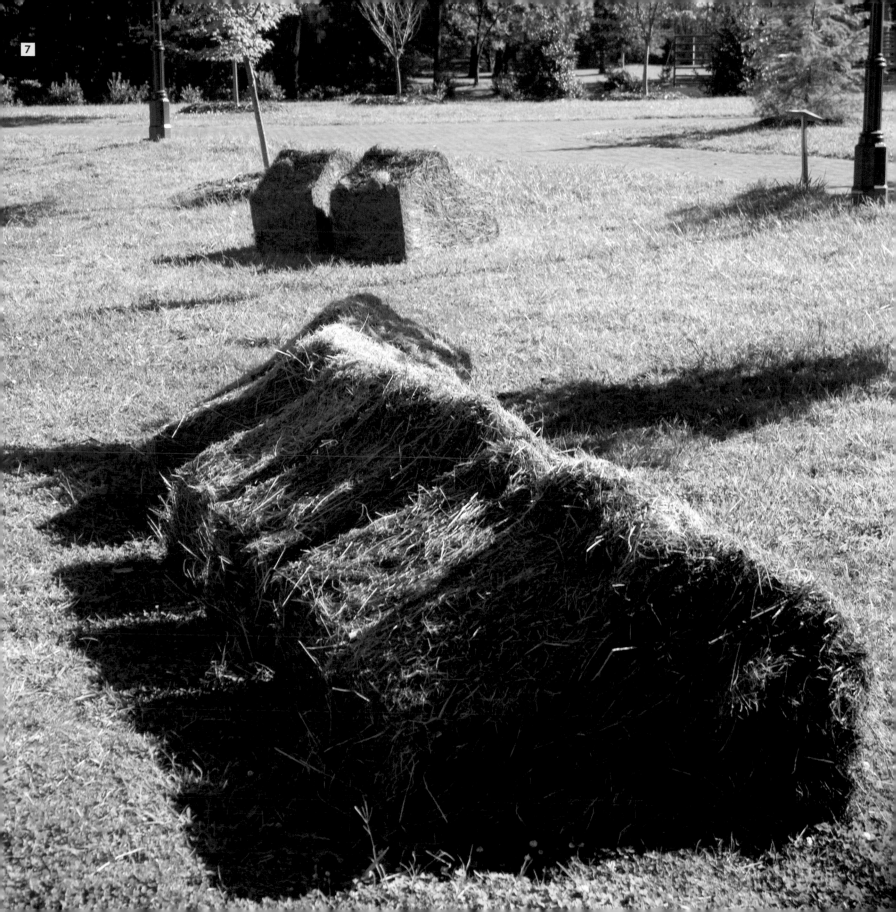

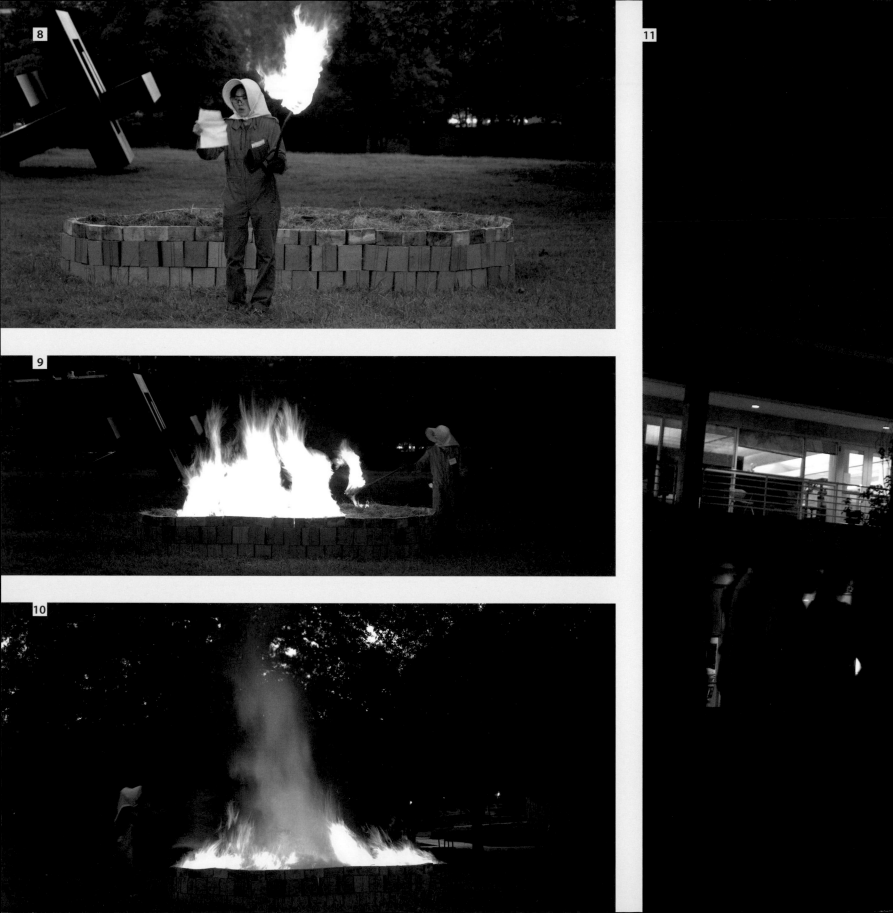

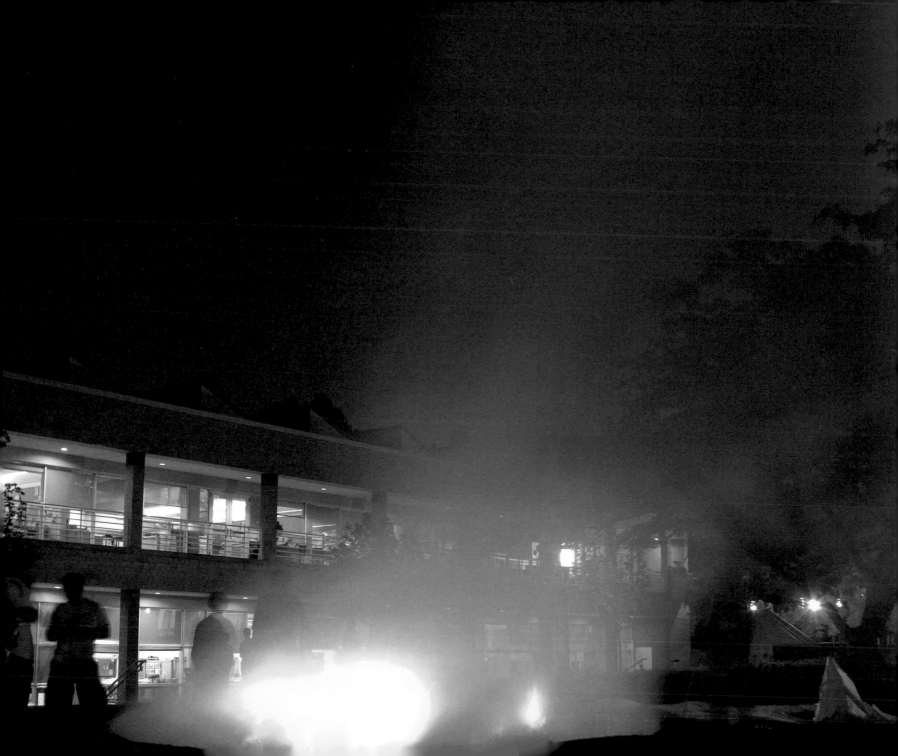

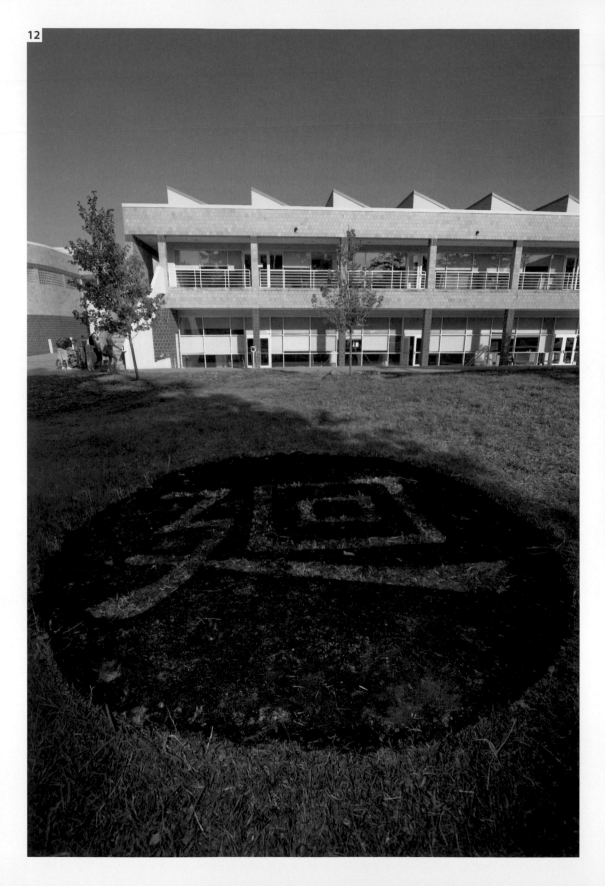

12

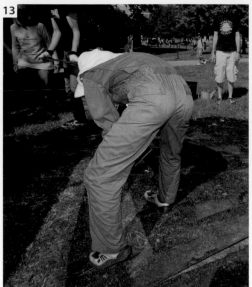

13

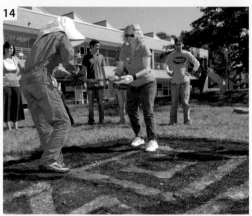

14

Figs. 8, 9, 10, 11: Before setting the piece ablaze, the artist read a statement about cultural identity and rituals. (Preceding pages)

Figs. 12, 13, 14: The tattooed landscape stated "circulation" or "recycle." This character was left for the UNC-Charlotte campus to experience its growth and rebirth.

Fig. 15: Gallery view displays the materials used in *Circulation*, as well as images of the various projects from outside. Aramaki left her red jumpsuit and hat hanging on the wall.

Additional image credits: Figs. 3, 4, 5, 12, 13, and 14 by Matt Parker.

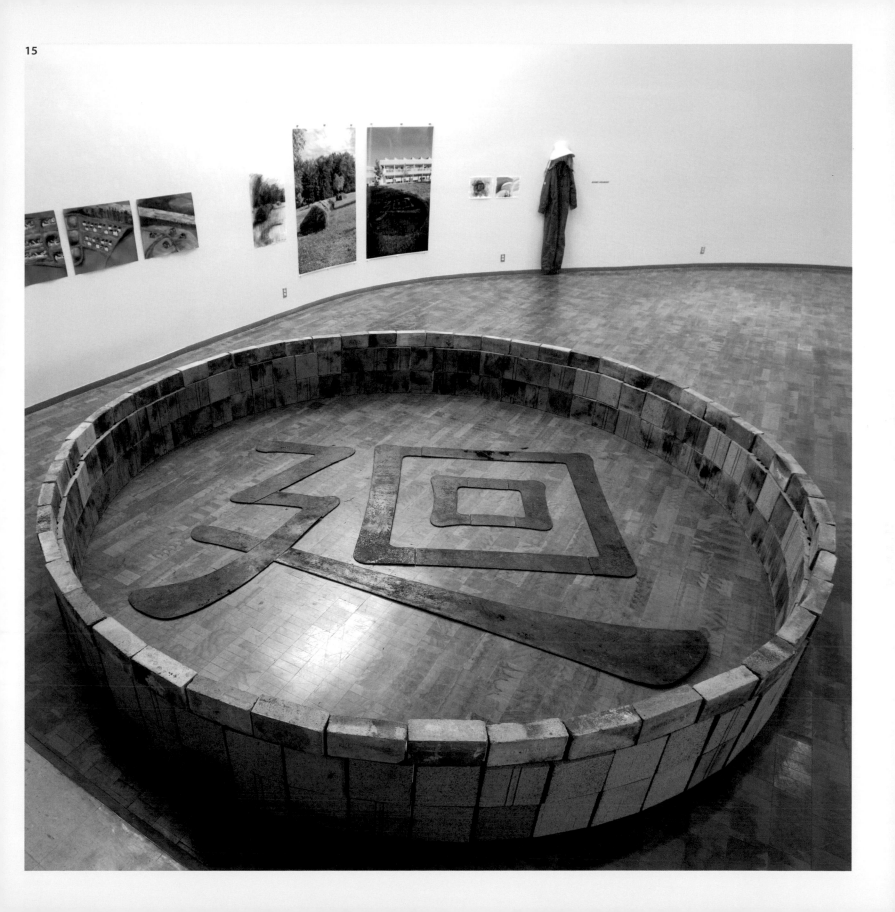

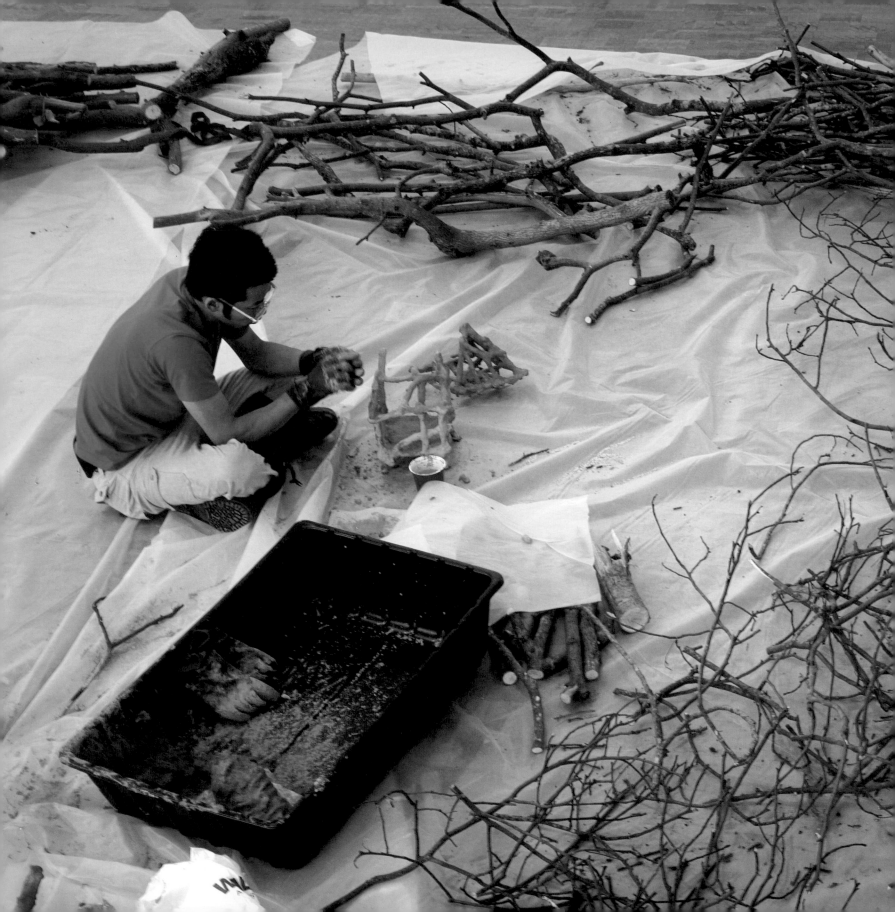

Akira Higashi
College of Architecture at
the University of North Carolina-Charlotte

Born in Hiroshima, Japan, in 1974, Akira Higashi received his B.F.A. in sculpture from Kyoto City University of Arts in 1998. He has had numerous exhibitions in Japan, including: Art Space Niji, Kyoto; Kodama Gallery, Osaka; Osaka Contemporary Art Center; and Gallery OU, Osaka. He was awarded the Kyoto Mayor Prize in 1998. He lives and works in Kyoto.

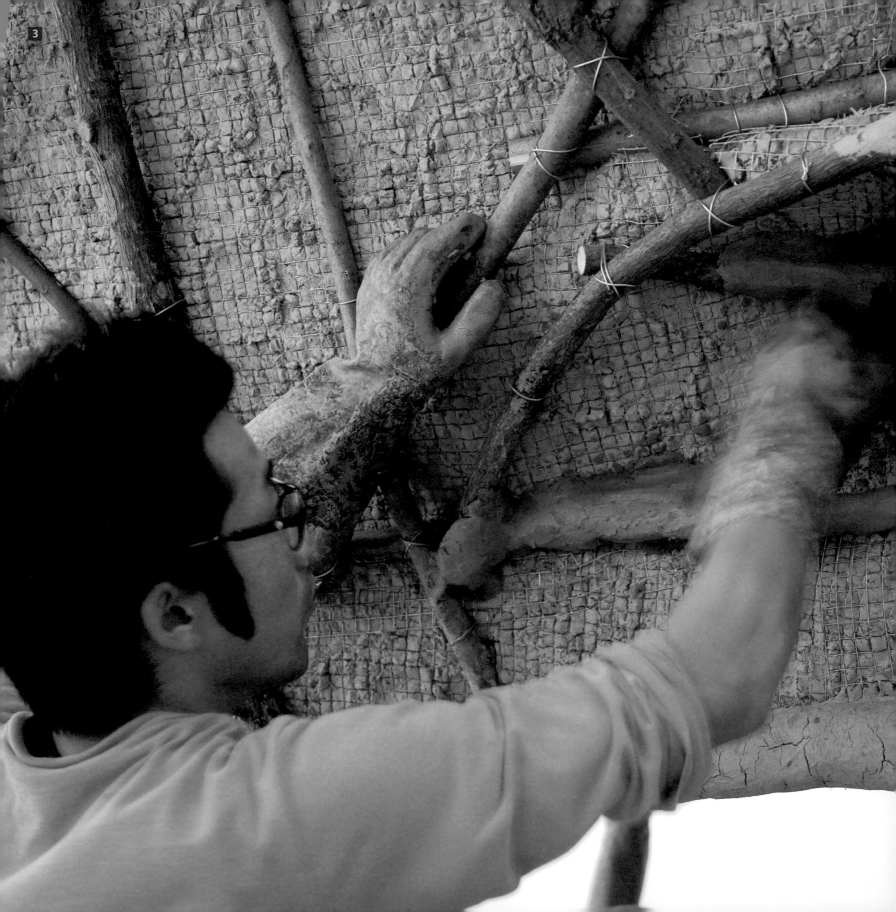

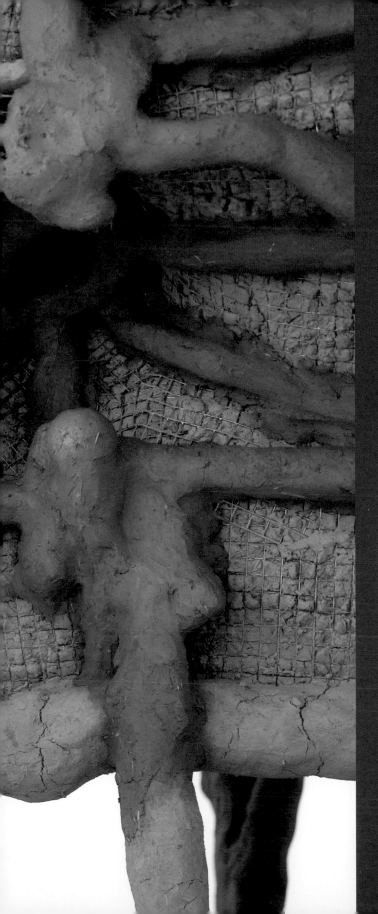

Class

Akira Higashi uses such traditional construction materials as clay, straw, and wood to create vernacular architectural enclosures based on the dimensions of the human body (figs. 3, 4). Viewers are invited to enter the works and experience the company of one another in isolation from the outside world (figs. 7, 9). These "communication machines" (as the artist refers to them) filter out the din of modern society and allow us to appreciate and focus on one another.

Long a student of African mud houses and other indigenous vernacular structures, Higashi was interested to learn of the clay in the vicinity of the University of North Carolina-Charlotte used by the Catawba Indians for their pottery. Once given a sample, he quickly realized this material would suit his needs well. He gathered sticks, branches, and twigs from the woods surrounding the campus, careful to use only fallen material, and began constructing his "class" from these locally available materials (fig. 1).

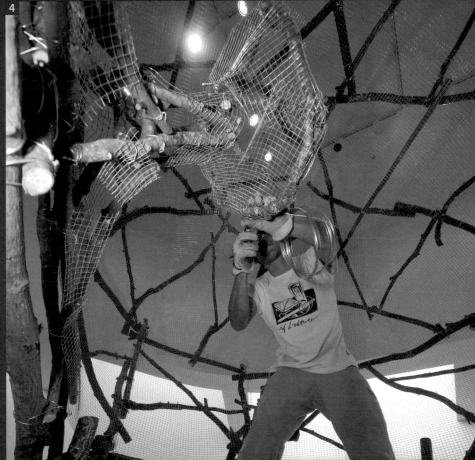

4

Higashi is interested in structures and relationships. He is curious about how one person relates to another, and how people relate to work, nature, and the structures they live in. His work is an attempt to bring our attention to this complex matrix of relationships. One of his discoveries upon coming to America for the first time was that Americans are very much individuals, in stark contrast to Japanese society, where the culture is more homogeneous. He wanted his work in Charlotte to reflect this dichotomy; he also wanted his work to reflect the context in which it is situated. Since a university hosted him, he created a classroom for the discussion of ideas.

Once inside Higashi's structure, viewers suddenly were removed from all familiar frames of reference. In this small chamber, we were forced to act and interact with one another in unfamiliar ways. By throwing us slightly off kilter, the artist hoped we would pay close attention to the metaphoric aspects of this experience. We are all alone in this world, yet a variety of people come in and out of our lives with important lessons and wisdom to share.

Higashi is intrigued by the paradoxical nature of inner and outer worlds. Those on the outside of the structure could see the feet of those on the inside (fig. 10). There was a heightened attention to the difference between seeing and being seen. The artist is interested in creating a multisided dialogue about people, the spaces we inhabit, and the communications that occur among us.

5

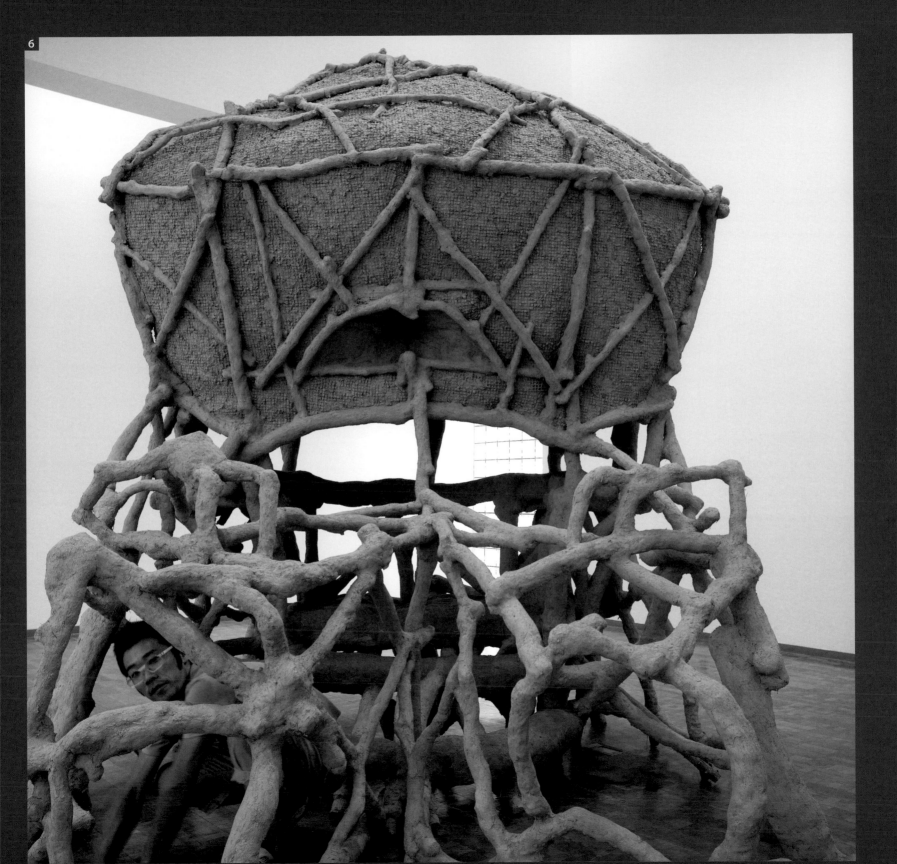

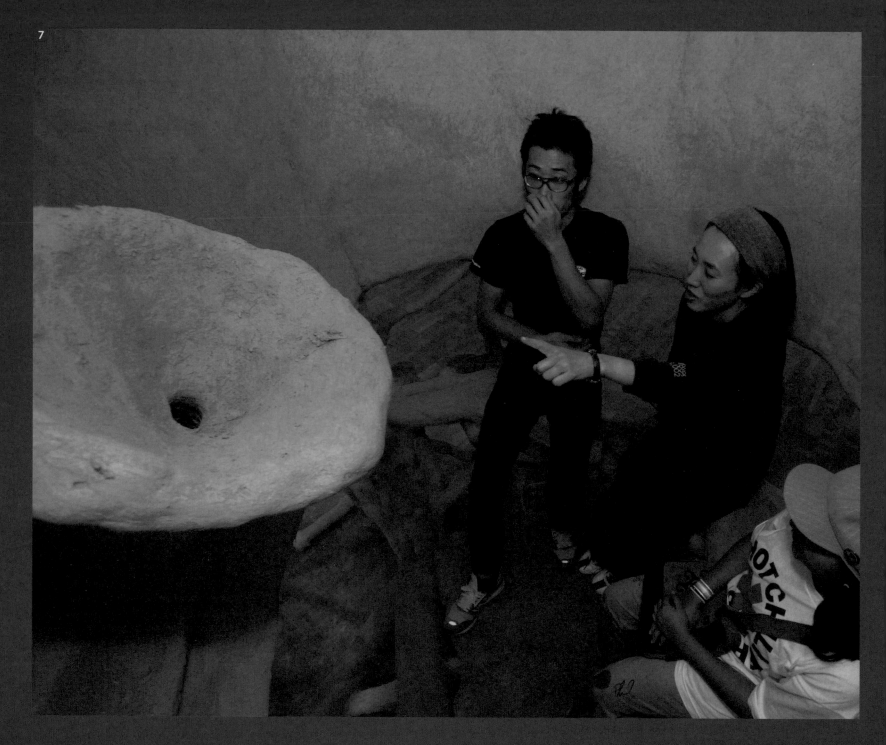

Figs. 6, 7: Higashi used his own body as the model for determining how others would maneuver through his work. Individual participants became a part of a homogeneous group, much like children in a classroom. (Preceding pages)

Fig. 8: The treelike attributes of *Class* presented the audience with an inviting interactive sculpture. The playfulness of climbing through the structure and into a space that might be associated with a tree house brought all participants to a common ground.

Additional image credits: Figs. 4, 7 by Matt Parker.

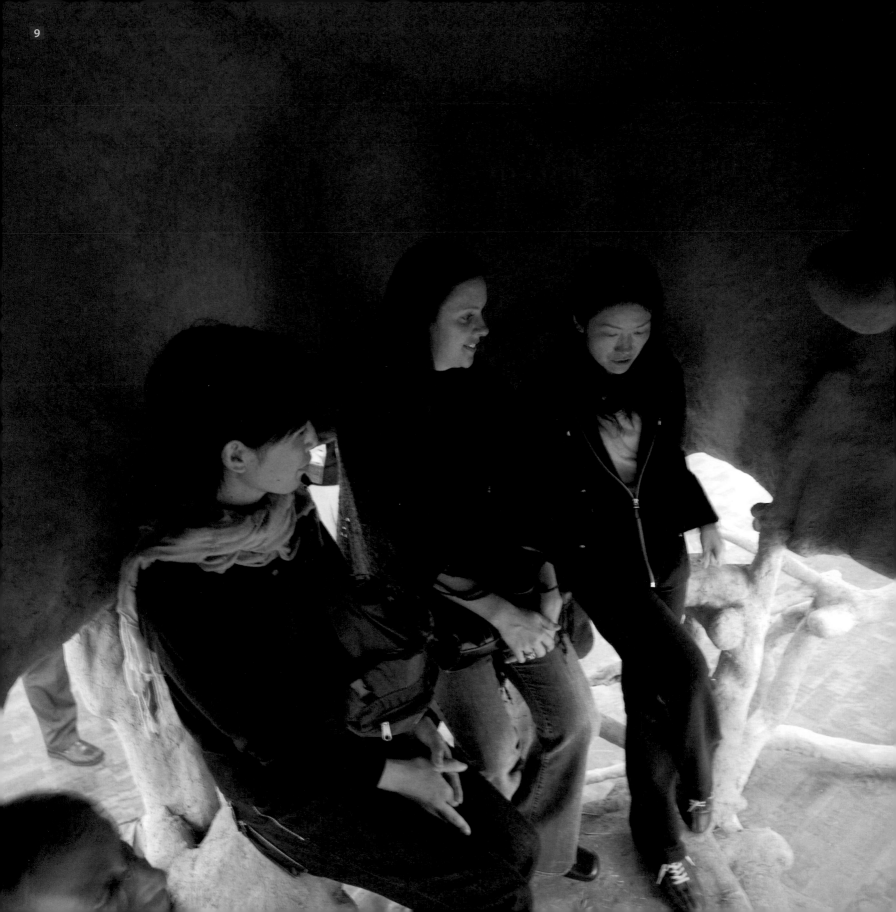

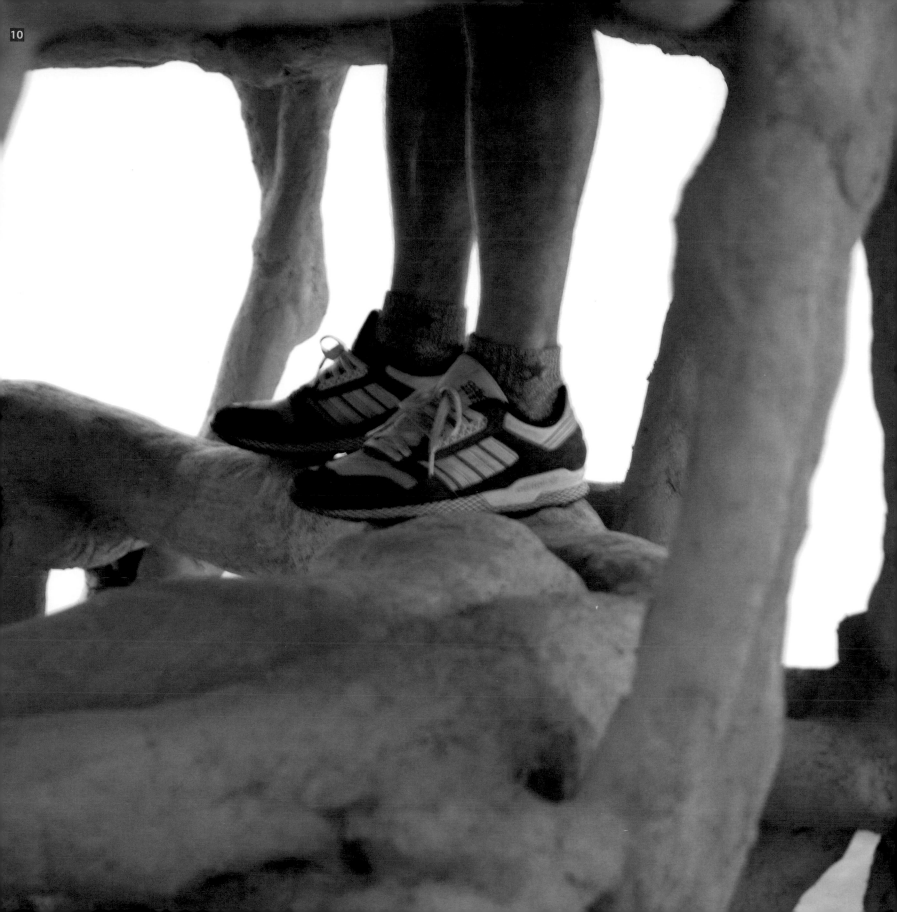

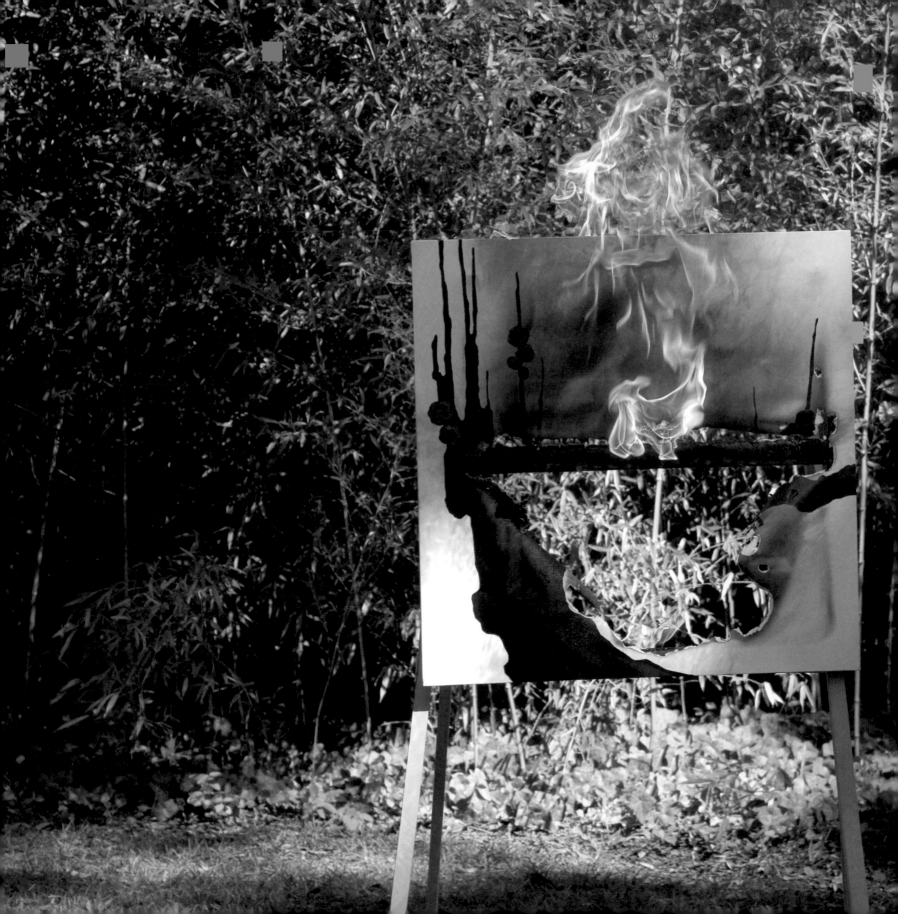

Junko Ishiro
Clemson Architecture Center in Charleston
Displayed at the Halsey Institute of Contemporary Art

Born in Shizuoka, Japan, in 1974, Junko Ishiro received her M.F.A. in oil painting from Tokyo National University of Fine Arts and Music in 2001. In Japan, where she has exhibited widely, her work is included in the permanent collection of the Dai-ichi Mutual Life Insurance Company. Her works have been shown at Gallery Hosokawa, Shizuoka; Prefectural Museum of Art, Shizuoka; the Ueno Royal Museum, Tokyo; Contemporary Art Space, Osaka; and the Museum of Modern Art, Gunma. Junko Ishiro lives and works in Osaka.

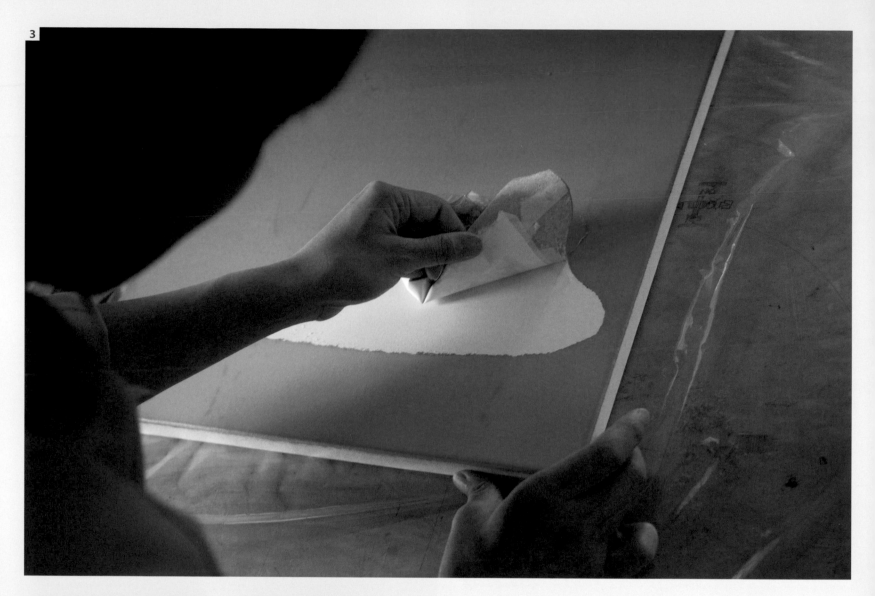

3

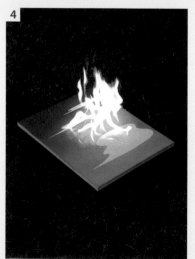

4

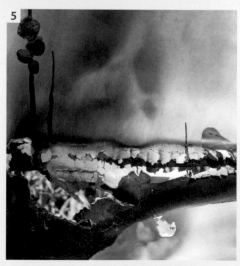

5

Manyo Wandering in the USA

Junko Ishiro approaches painting with iconoclastic zeal. Her seemingly straightforward oil paintings are at once a document of what is and is not present in the landscape. To emphasize this point, she has staged a number of performances in which she sets fire to the painting, in the natural or urban landscape, in the very spot it was painted (figs. 1, 2, 3, 4, 5, 6, 7). Through this act of destruction, Junko Ishiro creates a unique, four-sided dialogue among artist, subject, object, and viewer.

The *Man'yoshu,* or *Collection of Myriad Leaves,*[1] is the first major anthology of early Japanese poetry. In her effort to connect most efficiently with an American audience, Junko Ishiro turned for inspiration to an English translation of this Japanese classic text. Men, women, and children all contributed verse to this ancient volume. The poets included speak of their affinity for nature, their country, and the unique cultural traditions of Japan. The artist selected particular Lowcountry landscapes that approximate specific poems from this anthology.

Ishiro's paintings attempt to make the invisible visible. To her, a landscape is not synonymous with nature. Trees, mountains, and sky are merely visible components of much larger systems. Nature has the capacity to harm us, whereas a landscape is something we view within the frame of human vision. Ishiro believes that the only way we can begin to see the invisible threads of nature is if we perform an action that disrupts the natural flow. By burning her paintings in the landscape, she inserts herself, and her will, into the very fabric of the thing she wishes to understand. Then, in pairing her works with poetry in an interactive installation that utilizes video projection, animation, and two-way mirrors, the disruptions become confounding.

Early in her career as an artist, Junko Ishiro considered herself to be a landscape painter. Even then, she was more interested in understanding her place within nature than in depicting a realistic landscape. Applying a more philosophical approach to the interpretation of landscape, she seeks to explore the unseen relationships that exist between humans and nature. By enacting an almost ritualistic intervention, the artist inhabits the role of shaman. In this way, she is creating a space for viewers of her art to contemplate the ineffable.

The title *Manyo Wandering in the USA* offers a glimpse into the artist's sly sense of humor, by implying that she is a wandering eighth-century Japanese poet let loose on the contemporary American landscape.

1. *The Ten Thousand Leaves: A Translation of the Man'yoshu,* Japan's Premier Anthology of Classical Poetry, Volume One, translated by Ian Hideo Levy.

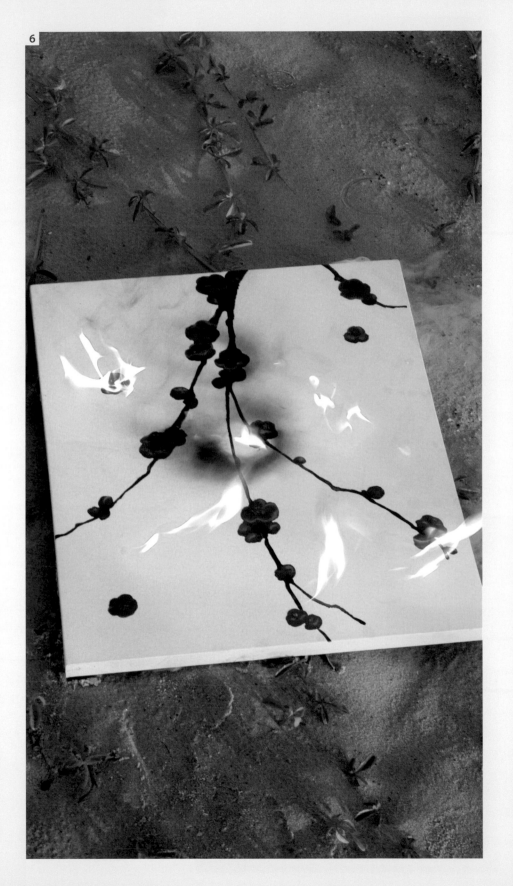

7

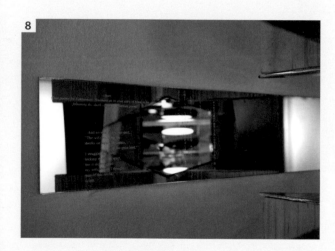

8

9

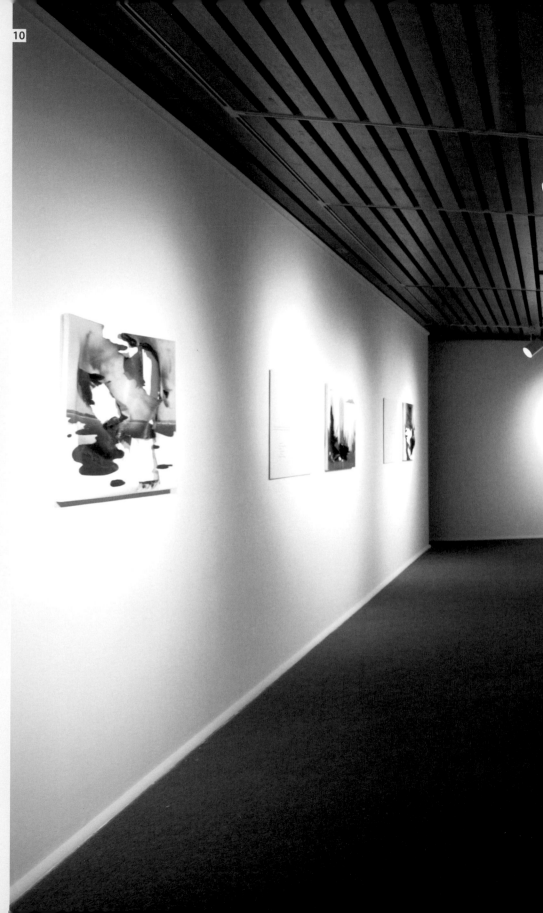

10

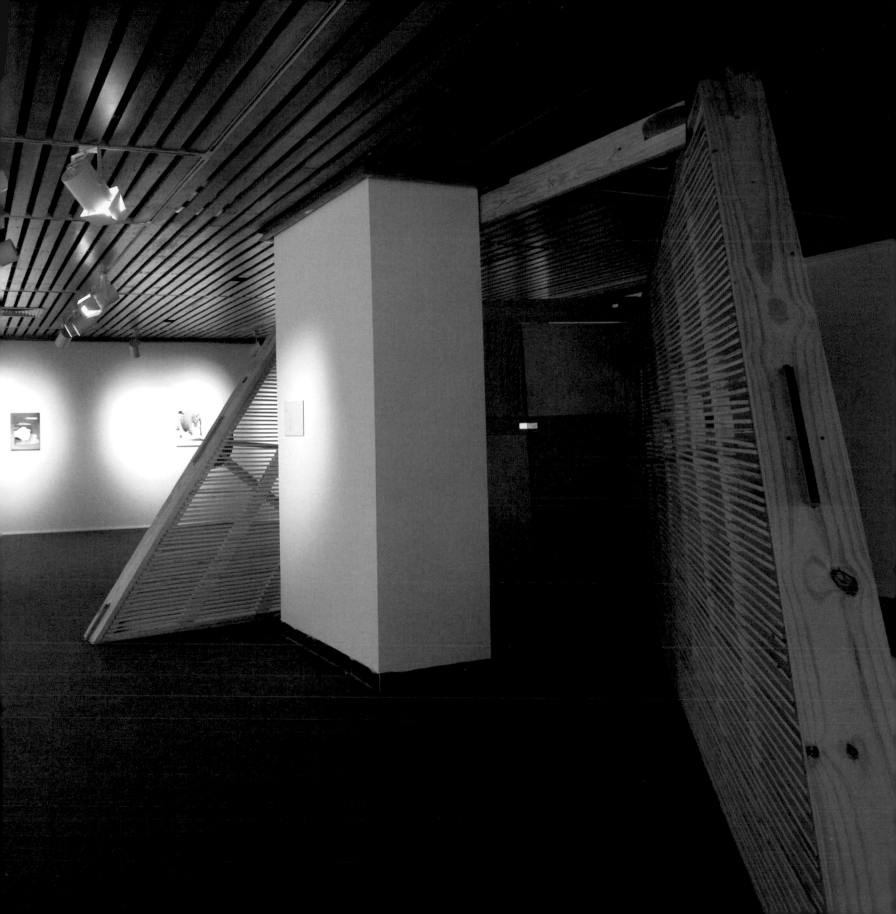

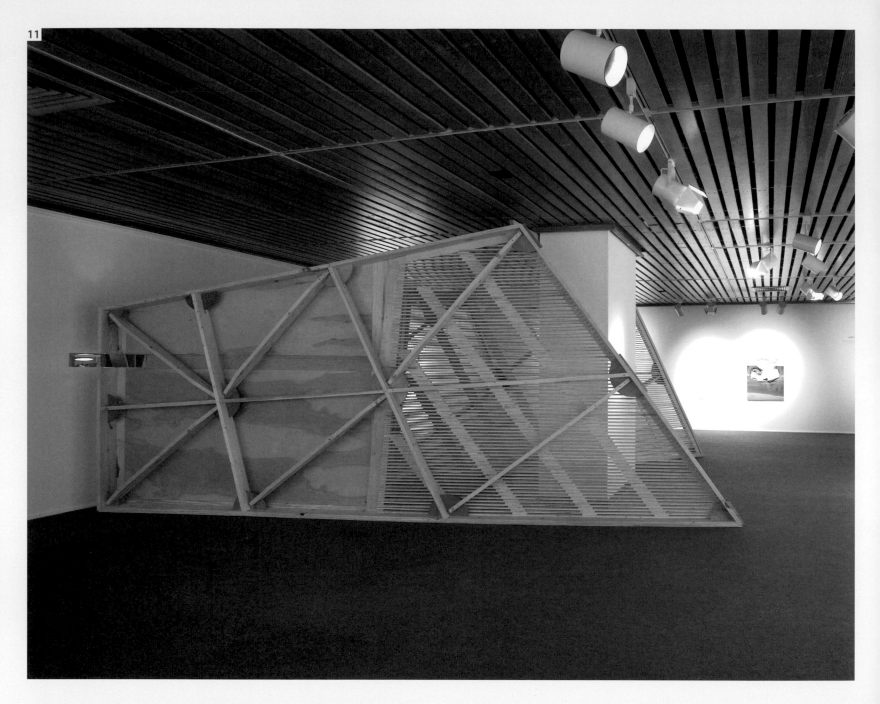

Figs. 8, 9: From the outside, on the back of the structure near the wall, a set of mirrors sat in a recessed shelf. On this shelf sat a glass dish filled with the ashes of the burned paintings. On the wall opposite the ashes a poem was silk-screened onto the mirror. The poem and the infinitely reflecting ashes suggested the confluence of space and time. (Previous pages)

Figs. 10, 11: With the assistance of Clemson Architecture students, Ishiro was able to present the interactive nature of her work with this structure.

Figs. 12, 13, 14, 15: As one looked through a viewing portal, there were two projected images with a two-way mirror between them. One side showed an animation creating the outline of natural forms. The other side showed video clips of Ishiro's paintings burning in the very landscapes where they were painted. Because of the precise placement of the two-way mirror, the human brain combined these two disparate images into one. (Fig. 15 on following pages)

Additional image credit: Fig. 13 by Robert Miller.

12

13

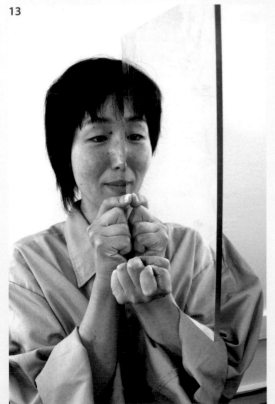

14

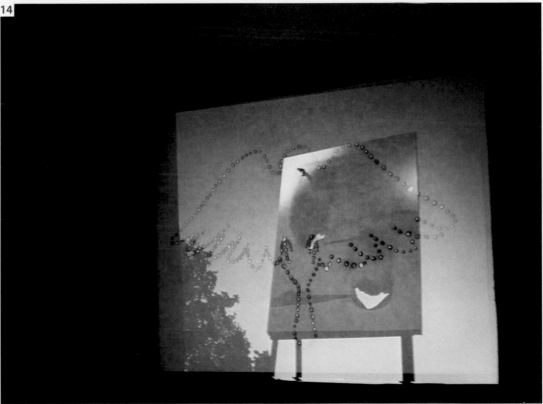

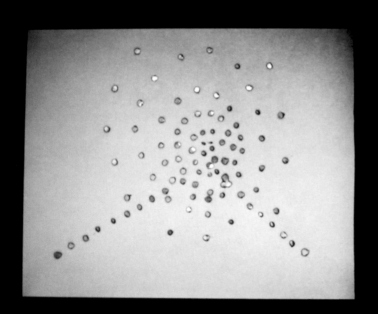

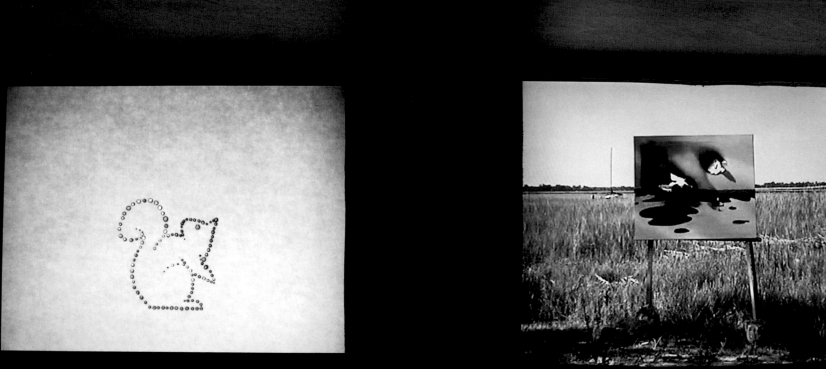

Aiko Miyanaga
McColl Center for Visual Art

Born in Kyoto, Japan, in 1974, Aiko Miyanaga received her B.A. in sculpture from Kyoto University of Art and Design in 1999 and her M.F.A. from Tokyo National University of Fine Arts and Music in 2004. Her exhibitions in Japan have been numerous. Her works have been seen at the Museum of Modern Art, Gunma; the Museum of Kyoto; Kyoto Municipal Museum of Art; Osaka Contemporary Art Center; and several prominent galleries. Aiko lives and works in Kyoto.

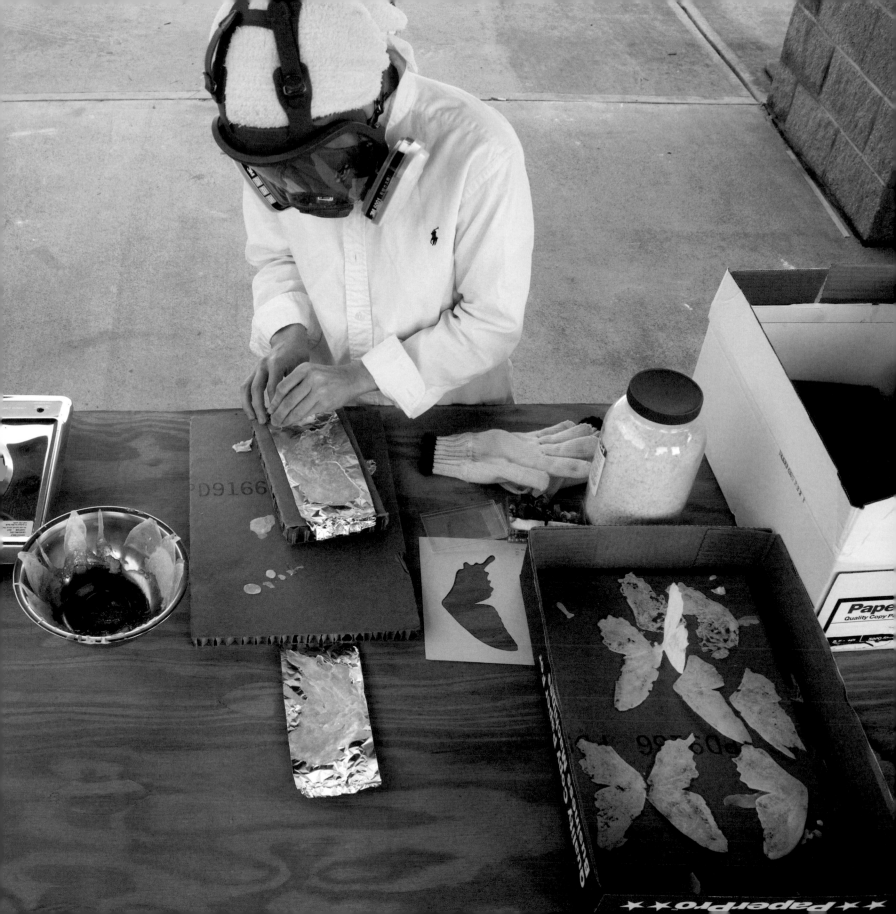

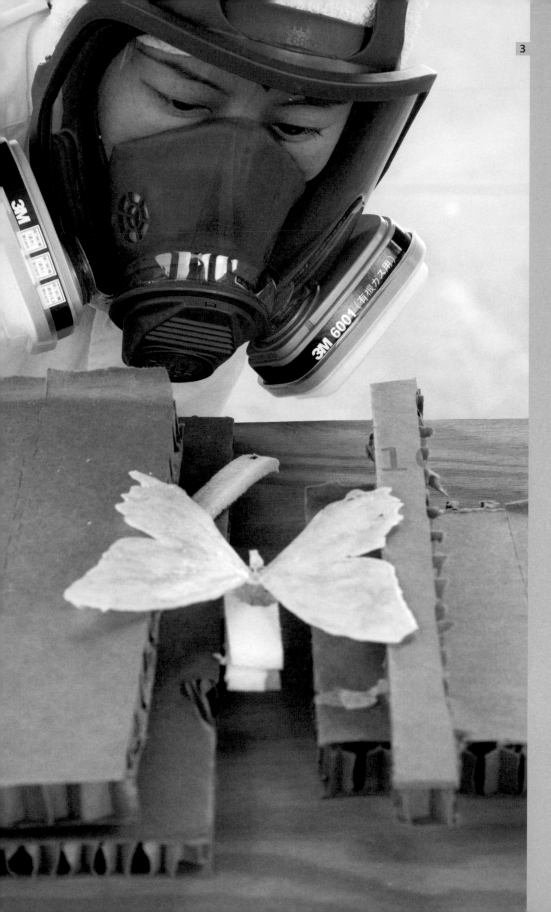

Seven Stories

Naphthalene is a synthetic material most commonly found in mothballs, which are used to repel moths from household closets. Aiko Miyanaga creates molds of such things as shoes, shirts, dresses, and butterflies, and casts them in naphthalene. The delicate, aromatic objects are identified with a handmade label and enclosed within Plexiglas vitrines. Over the course of an exhibition, the objects slowly evaporate from exposure to the air (figs. 4, 11, 12). As the naphthalene collects on the inside of the vitrine, it forms crystalline shapes that signify the ephemeral nature of all things.

Naphthalene is an important chemical in Japan, as it is elsewhere in the world. Many Japanese households switch from winter to summer clothing, and vice versa. This annual fall and spring ritual is accompanied by the pervasive odor of naphthalene. It is ironic that the very chemical used to preserve something else is itself quite short-lived.

For her installation, entitled *Seven Stories*, at the McColl Center, Miyanaga created an array of mysterious objects for viewer contemplation. These narrative fragments were dispersed inside the historic building that the McColl Center occupies. There were six objects, each with a particular set of associations, placed strategically throughout the building. The "seventh story" was to be provided by each viewer as they contemplated the works, their context within the building, and themselves, in relation to the work, the building, the environment, their mood, and so on. In this way, the artist created a dynamic and interactive work that engaged all of the senses. For instance, one of the six works was a ceramic bowl created by the artist (figs. 6, 8). She researched various glazes, coming up with a special one that continues cracking as the pot ages and is exposed to various changes in temperature, humidity, etc. As the glaze cracks,

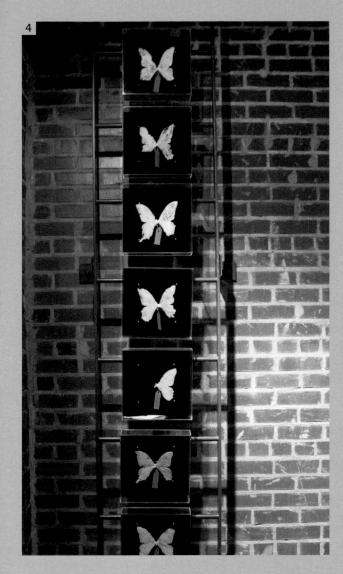

4

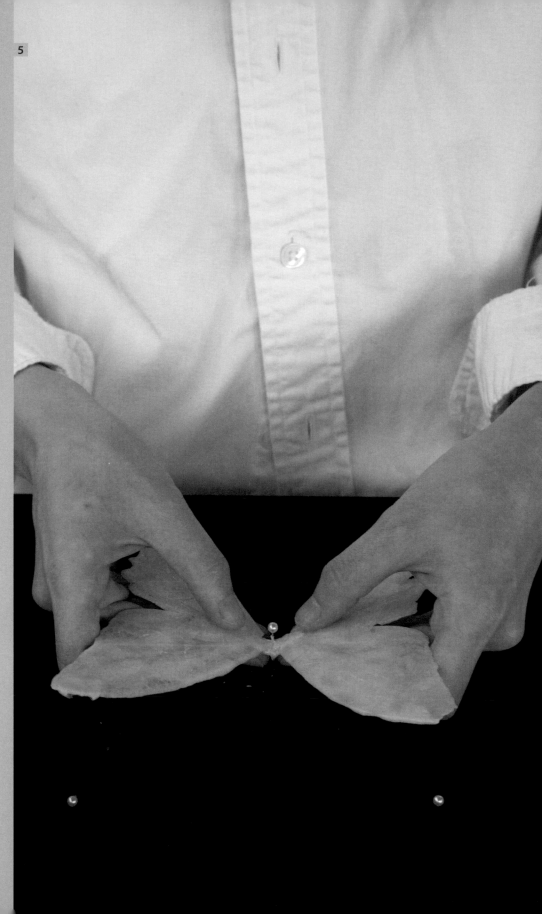

5

it makes a distinct cracking sound. Thus, the artist tangibly demonstrated that all things change all the time. Nothing is fixed.

The naphthalene works were obviously ephemeral; their lifespan was only a matter of weeks. The artist is unconcerned that her work does not last. In fact, that is exactly the point: Her work is about impermanence and the passage of time. Miyanaga hopes it inspires viewers to have a greater appreciation of the people and things that surround them at this moment, because all of this will change: "The most important things are not those that happen before your eyes," she says, "but behind them."

6

Fig. 6: Placing the tea bowl above the viewer on a suspended glass shelf, the ceramic bowl functioned as an object to be listened to, the special glaze cracking as it ages. The function was altered specifically for this installation—to be seen as a product of time rather than an object for holding things. Looking up often relates to contemplation, humbleness or both.

Fig. 7: The audience members participated in an opening-night tea ceremony. They were asked to listen to the tea bowl as the artist poured tea into bowls made by several generations of her family.

Figs. 9, 10: A piece of string was soaked in seawater collected from Charleston Harbor, in South Carolina. The water evaporated and left salt on the string, which was suspended for three stories in the stairwell of the McColl Center. (Following pages)

Figs. 11, 12: Creating keys and shoes with naphthalene, the vitrines collected crystalline shapes on the inside, signifying the ephemeral nature of all things. Keys and shoes are the daily objects that invoke the passage of time. (Following pages)

7

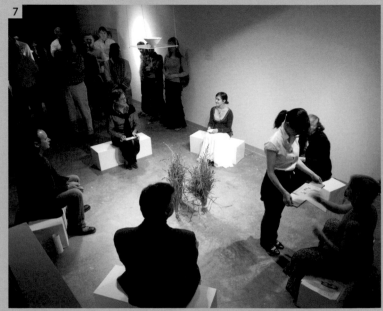

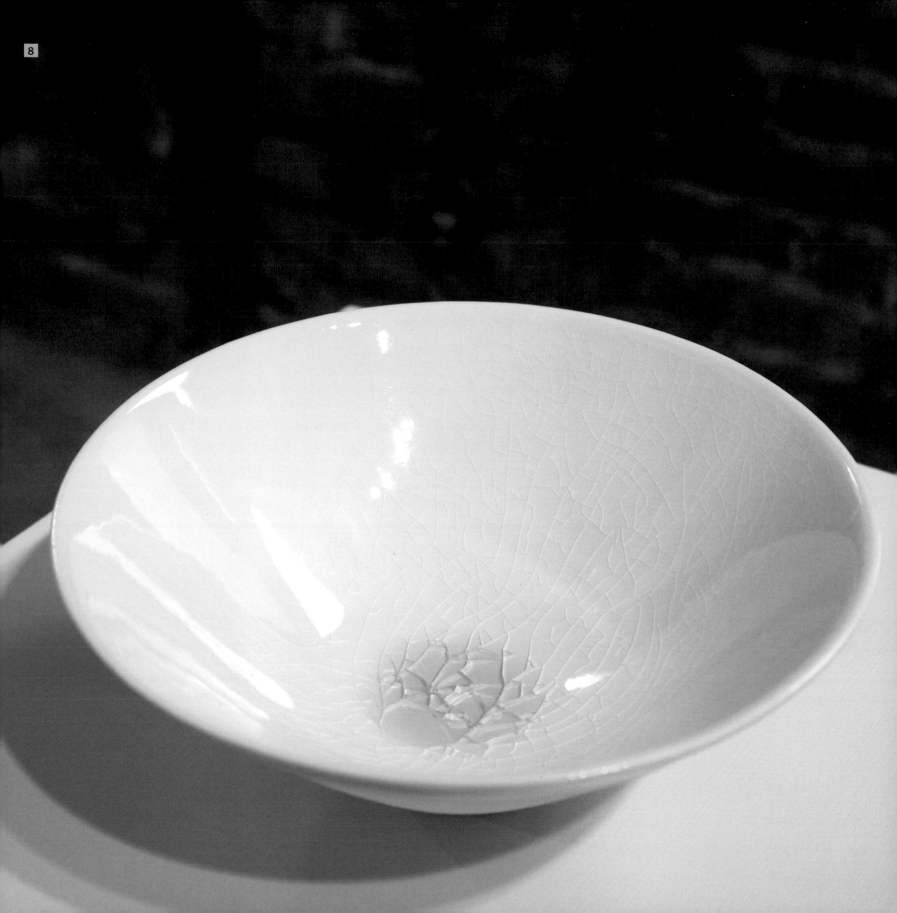

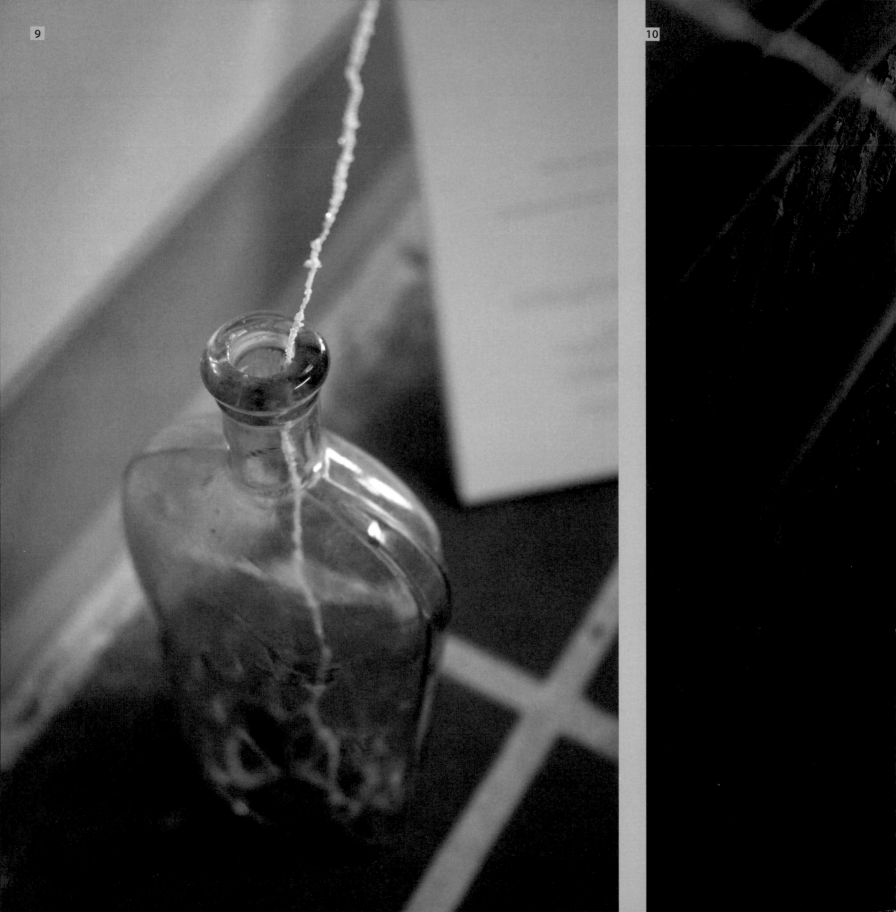

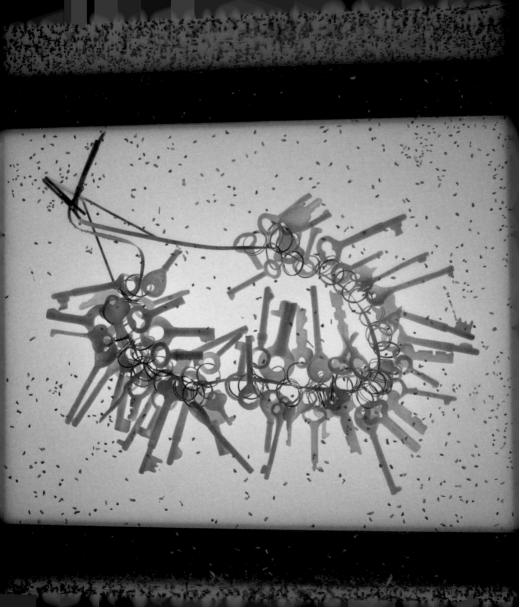

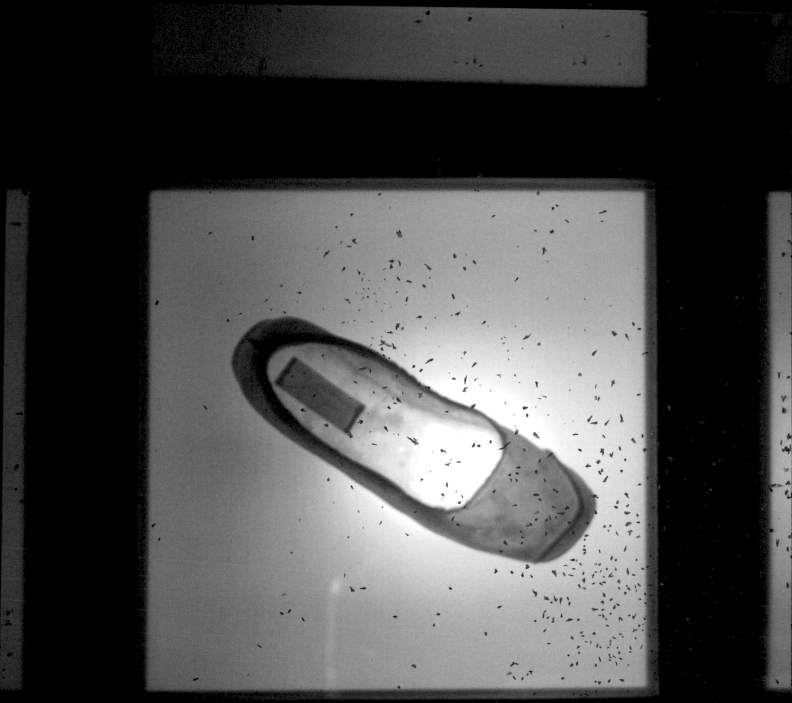

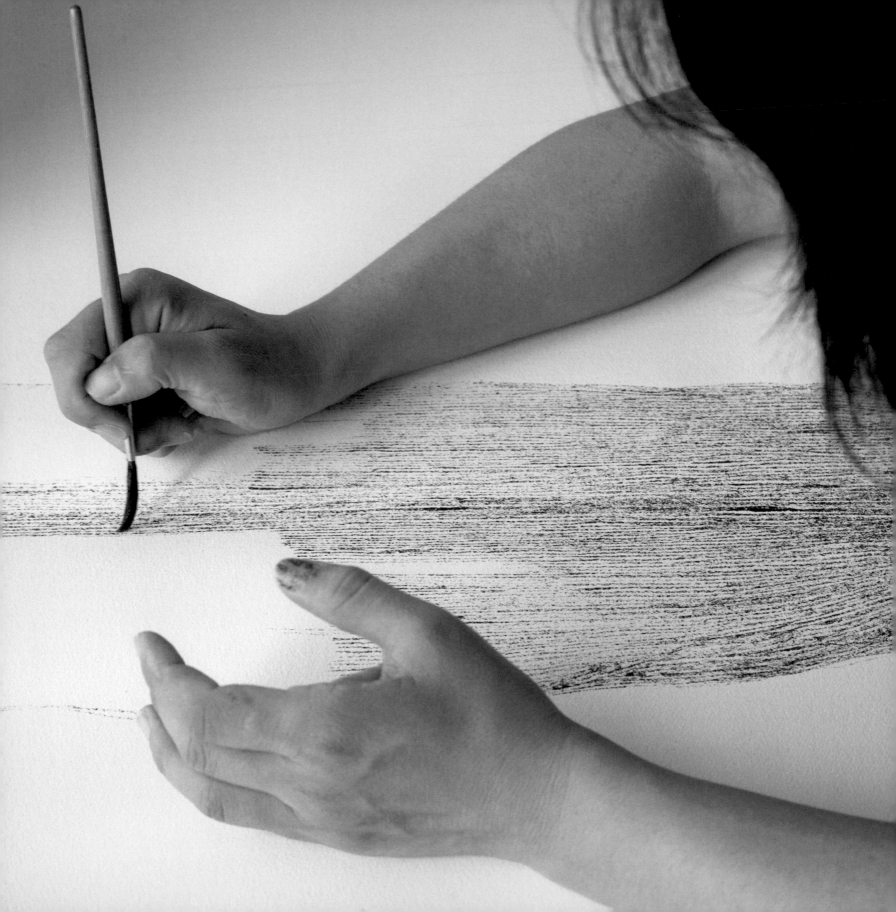

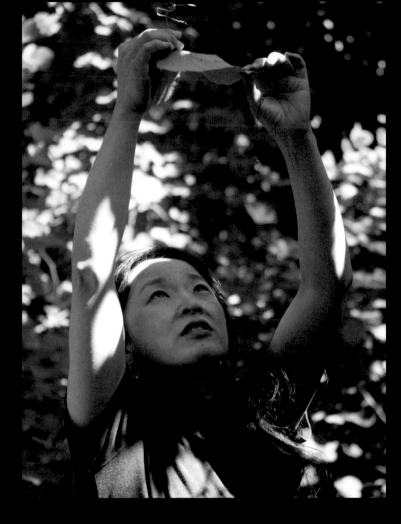

Born in Hyogo, Japan, in 1960, Yuri Shibata received her B.A. in printmaking from Kyoto Academy of Fine Art in 1983. She has had several exhibitions in Japan. Her works have been shown at the Nariwa-cyou Museum, Okayama; Kyoto City Museum; Modern Art Museum, Hyogo; Okayama Prefectural Museum; and Ferishimo Museum, Hyogo. She had an exhibition at the Tokyo Museum of Contemporary Art. The winner of several awards, including the grand prize at the Tokyo Central Museum's print exhibitions in 1984 and 1985, Yuri Shibata lives and works in Osaka.

Material Works

Since the beginning of her artistic career, Yuri Shibata has been interested in the question of boundaries between herself and nature. "How much of nature is in me, and how much of me is in nature?" she asks. "How much is me; and how much is no longer me?" These are the philosophical underpinnings that inform all of the artist's works. To answer these questions, she immerses herself in the ephemera of her surroundings. A number of performance-related projects have led her to examine various environs and to filter that experience through tangible works of art that convey a more accessible and potent message to the viewer. This concept is best exemplified in a series of prints made from daily collections of dust from museum galleries. She has also ground pigments and prepared paints from such natural materials as cherry blossoms and her own hair (fig. 1). This paint was then used to produce an image of the object that had been destroyed to make the paint.

For her exhibition at Davidson, Shibata presented several related works in a variety of media with these common themes. She collected dust from various areas of Davidson's Belk Visual Art Center each day, and produced a series of *Dust Prints*, each representing one day's accumulation (figs. 3, 4, 5, 6, 12). Because dust is made up of decaying human skin, among other things, the human trace is contained within it. We all return to dust at some point, and these prints provide a playful reminder that our days are numbered. *Air* was a complex work involving the videotaped breathing of a series of nude subjects. The artist asked her subjects to relax and breathe deeply for her sessions. These images were then projected down onto a specially created latex structure that breathed along with its subjects (fig. 10). Shibata emphasized the point that we are all born naked and die naked—yet, during life

We all share the act of breathing. This installation reinforced the commonalities of all peoples—here, Japanese and American—yet revealed the individual distinctiveness of each subject.

Material Color works were about the harvesting of some natural material (hair, kudzu, etc.) to be ground into pigments and made into paint. The resulting paintings were both of and by their subjects. One cannot conceive of a more completely representational art form. In *Material Work: Hair*, the artist created a painting of her hair with actual trimmings of her own hair (figs. 1, 9). At the opening reception, she cut her hair in the same amount represented in the painting (fig. 11). The circularity of logic involved in the conception of this work finds echoes in the works of other artists in the *Force of Nature* exhibition.

For Shibata, the world around us is an extension of ourselves. Her curiosity about our boundaries brings into question the very nature of human nature.

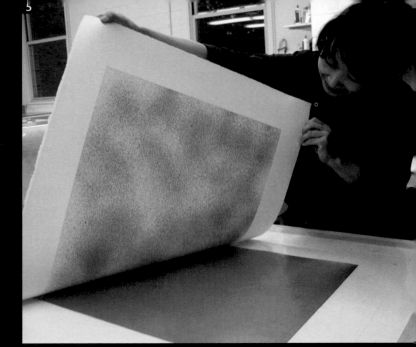

5

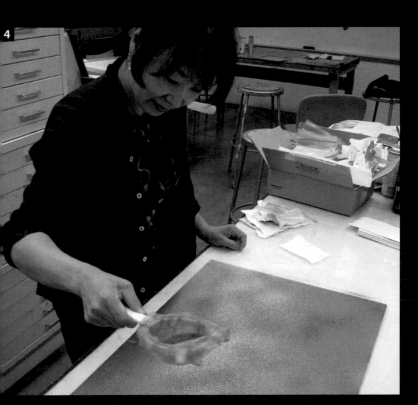

4

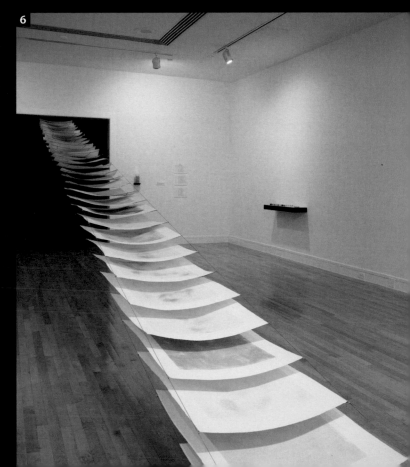

6

Figs. 4, 5, 6: Shibata created a series of prints, each using dust collected on a particular day. The dust is the residue of our presence, our existence. By creating prints using dust, she is capturing time—not our present time but the near past.

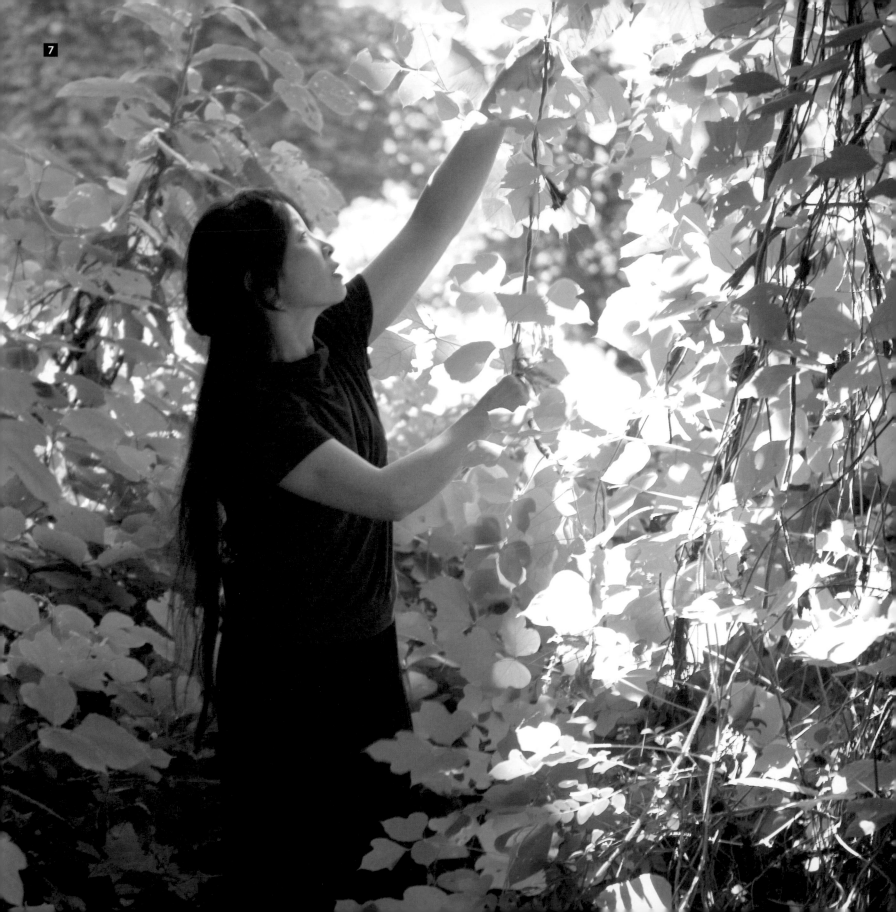

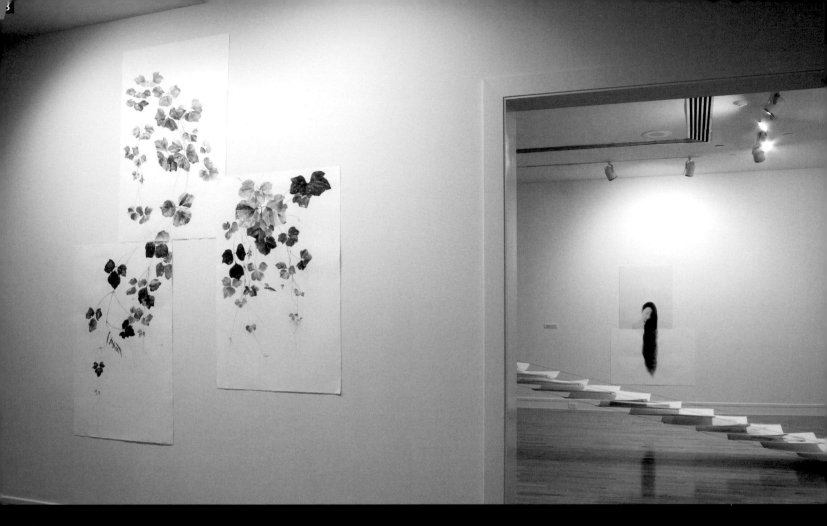

Figs. 8, 9: Native to Japan, kudzu was brought to the United States in 1876, as part of a Japanese garden display for the Centennial Exhibition in Philadelphia. Finding the large presence of kudzu in North and South Carolina, Shibata wanted to use this familiar plant. Taking kudzu and grinding it, she then mixed it with an adhesive to create a pigment. Using the pigment, she painted kudzu with the ground kudzu.

Figs. 10, 11, 12: Gallery view of *Dust Prints*, implying falling dust; performance piece cutting hair; painting of hair. (Following pages)

Additional image credits: Figs. 4, 5, 8, 14 by Brad Thomas.

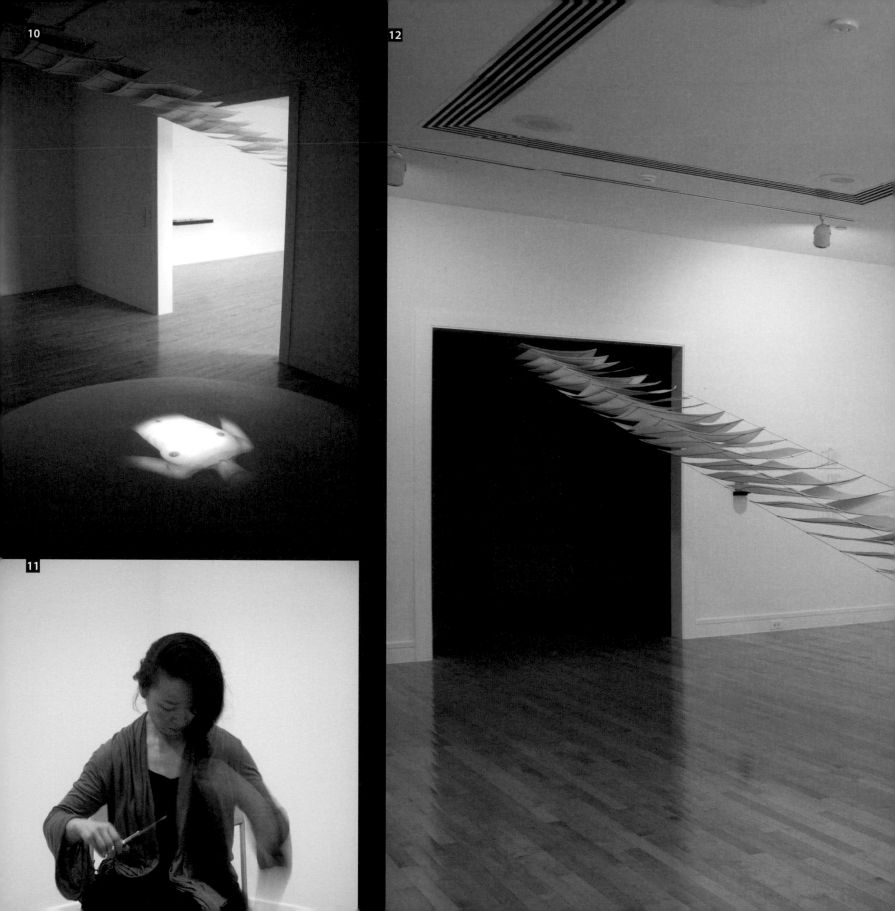

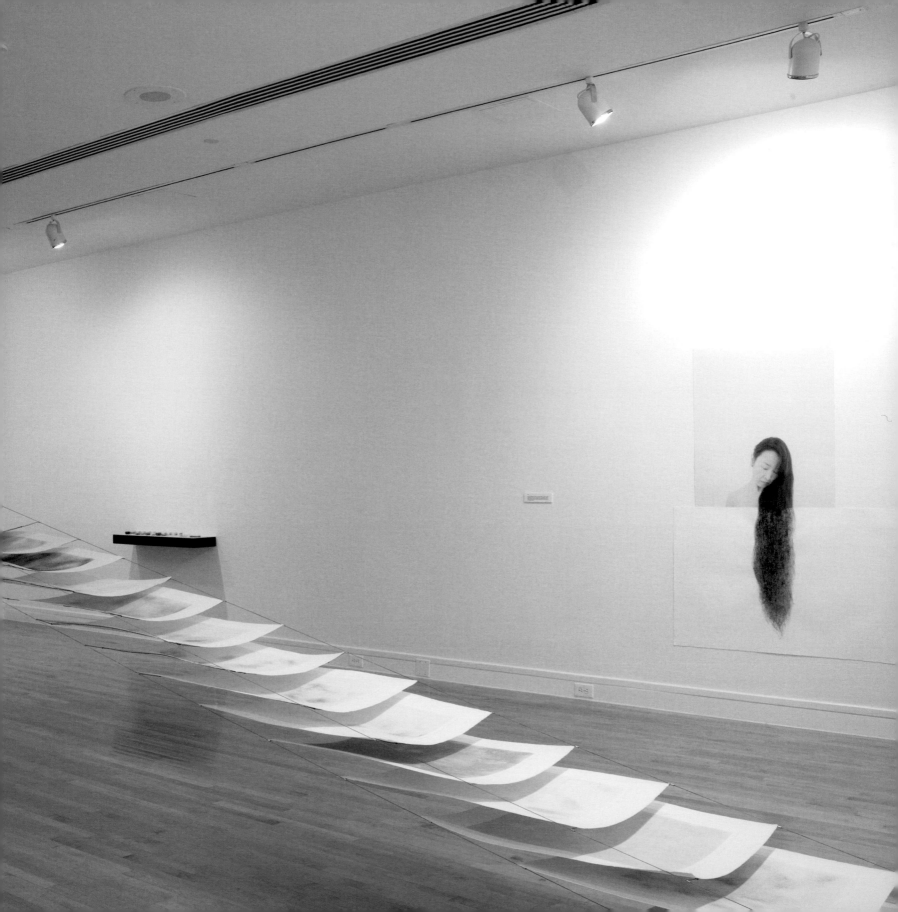

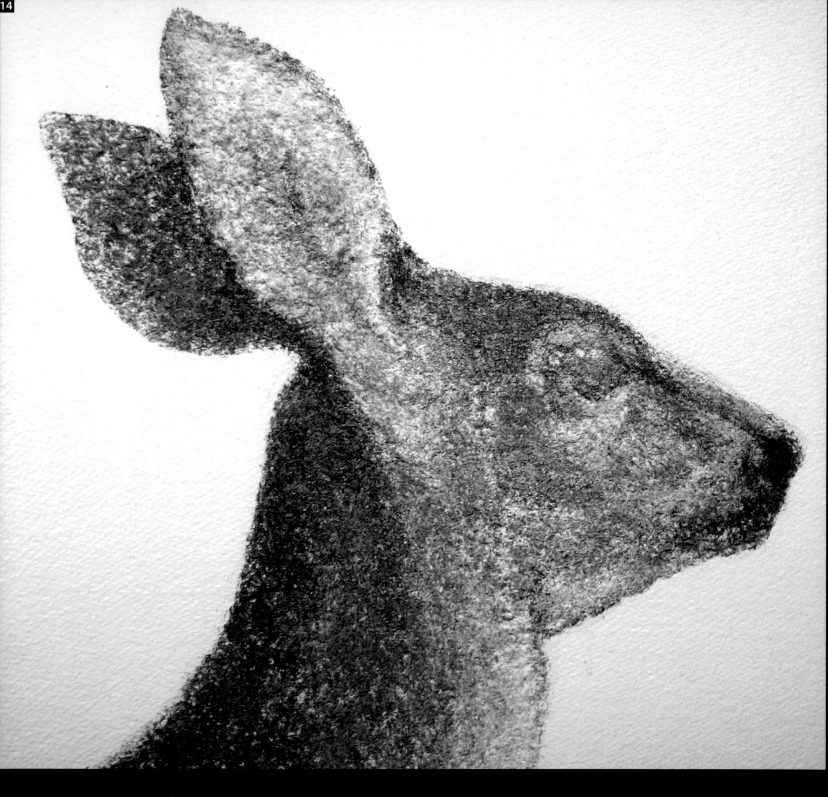

Figs. 13, 14: Using the pelt of a Carolina white-tail deer, Shibata removed hair from the variously colored areas and ground it into a pig-ment. With this, she painted a deer using specific pigments to depict its variegated colors.

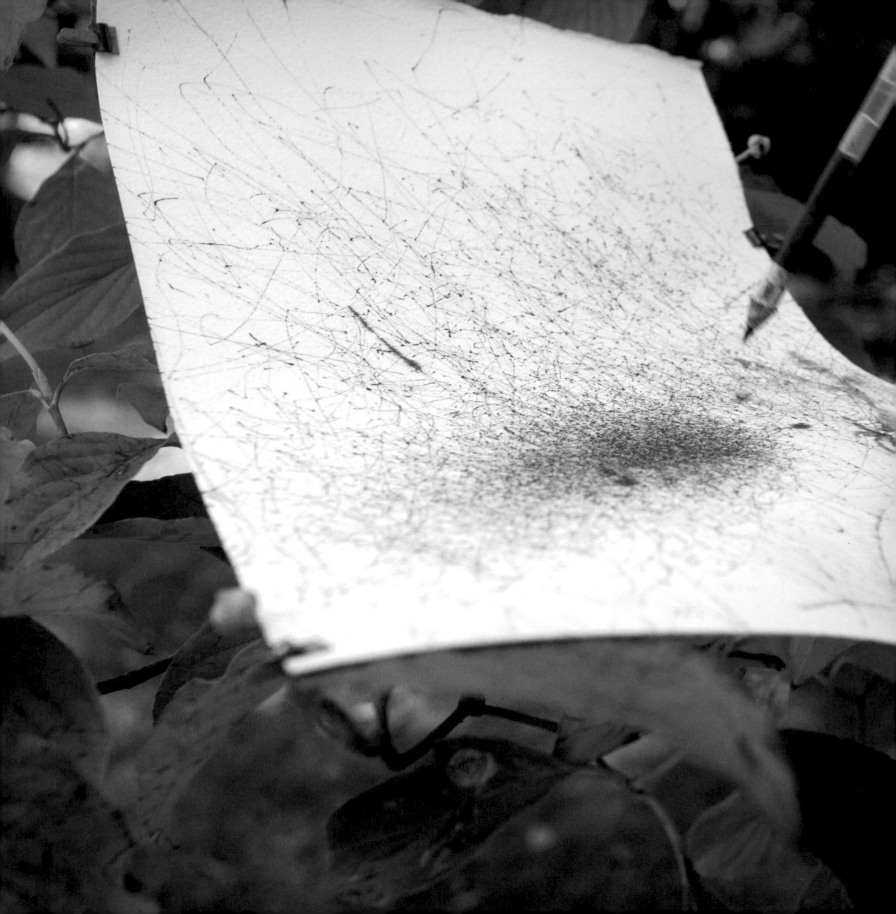

Rikuo Ueda
Winthrop University Galleries

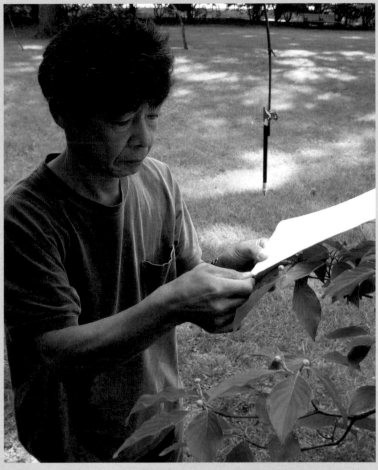

Born in Osaka, Japan, in 1950, Rikuo Ueda has had numerous exhibitions and residencies in Japan and internationally. Residencies include: Indiana University, Bloomington, Indiana; Wabash College, Crawfordsville, Indiana; and the College of Charleston, South Carolina. His work is included in the permanent collections of the Goethe Institute, Kansai, Wabash College, and the College of Charleston. His works have been exhibited at the Emba Art Museum, Hyogo, Japan; National Art Gallery, Malaysia; Tokyo Metropolitan Museum, Japan; Invetro Gallery, Hannover, Germany; International Workshop for Visual Artists in Remisen Brande, Denmark; Ikon Gallery, Birmingham, England; Perron 1, Delden, Holland; CAI, Hamburg, Germany; and many more. Rikuo Ueda lives and works in Osaka.

Southern Comfort:
I Wait for Wind 30 Days in Room 305

Rikuo Ueda sets into motion elaborately engineered mechanical devices designed to harness the wind so that he may create his "wind drawings." A writing instrument mounted on a flexible arm records both subtle and dramatic variations in the wind by transferring the energy onto paper, canvas, or another surface. The "machines" are often constructed of such natural materials as bamboo and hemp

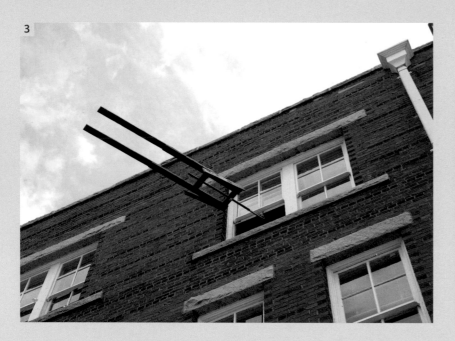

rope, making the structures themselves beautiful and sophisticated in design. For *Force of Nature*, Ueda employed a diverse array of wind machines, using a variety of materials and methods. Based in room 305 of the Fine Arts Building at Winthrop University (figs. 3, 4, 5, 6, 7), the artist also set up multiple wind-drawing stations around campus (figs. 1, 2, 8, 9, 10).

As a young man, Ueda set out for a three-month travel adventure that turned into three years. Upon his return to Japan, he was at a loss for what to do with his life, until he decided that his aim was to be "aimless." Of course, becoming aimless required an aim! He decided that this would still be possible for him, if only in a small way. Thus, he prefers to live each day as an adventure, without planning too much.

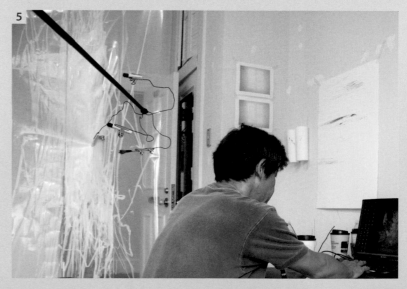

His reply, when asked why he works with wind, reflects his approach to life. He literally stumbled onto using wind while participating in an artist's residency in Denmark. The other artists in the program were working industriously while Ueda was casting around for what he might do with his time there. He came upon an abandoned railway worker's shed and began poking around inside. He started putting a few things together, and then stuck something out the window to catch the wind. This early wind machine created a small drawing inside the shed. This drawing was a document describing the wind's motion at a specific time and place. When one of the other resident artists saw this, he said, "So, that's what you do! Interesting." Since that time, he has made wind drawings.

Rikuo Ueda's favorite artist is Henri Matisse. He likes Matisse because his work is full of joy and makes one smile. Ueda says that whenever people stop and ask what he is doing, they break into a smile when they hear, "Wind drawing." This is the motivation that keeps him going. The urge to bring joy by demonstrating the beauty of nature seems to be his special gift. He has learned that if one wants to work with nature, one has to be imperfect or "loose." Rigid attempts to overcome nature are doomed from the start. He collaborates with nature to provide a model for how we might coexist with our surroundings.

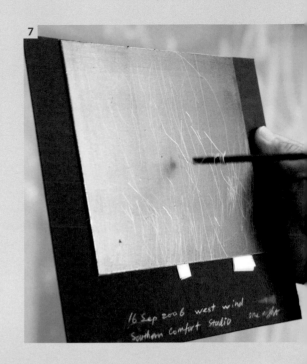

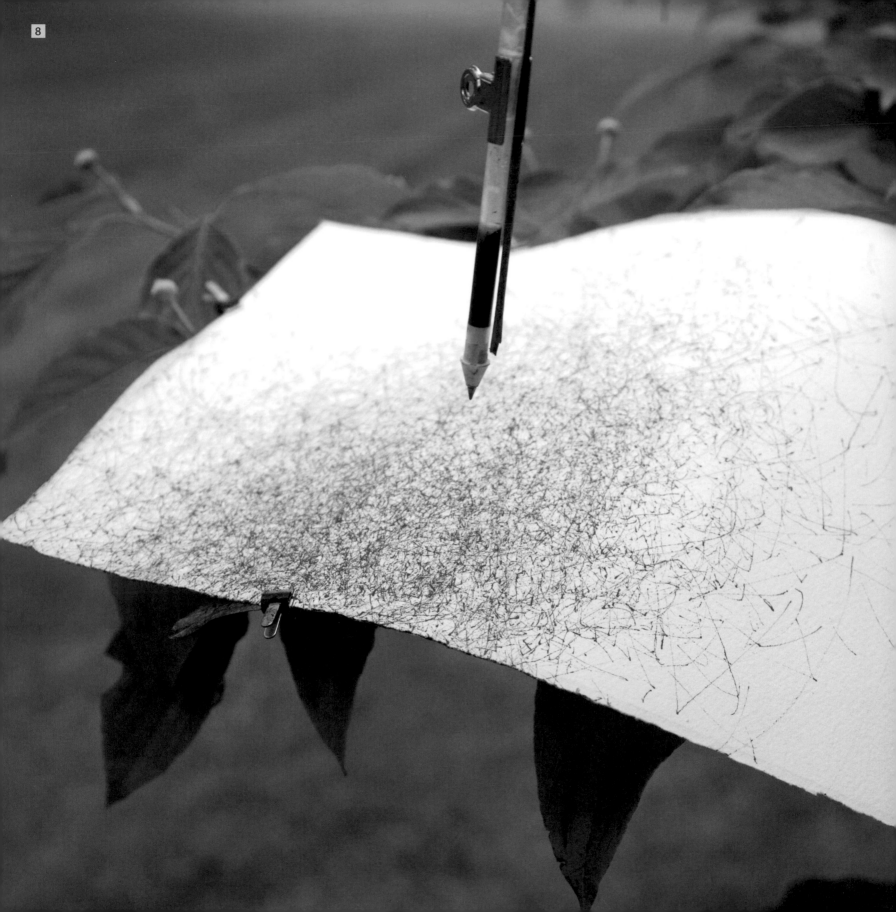

9

10

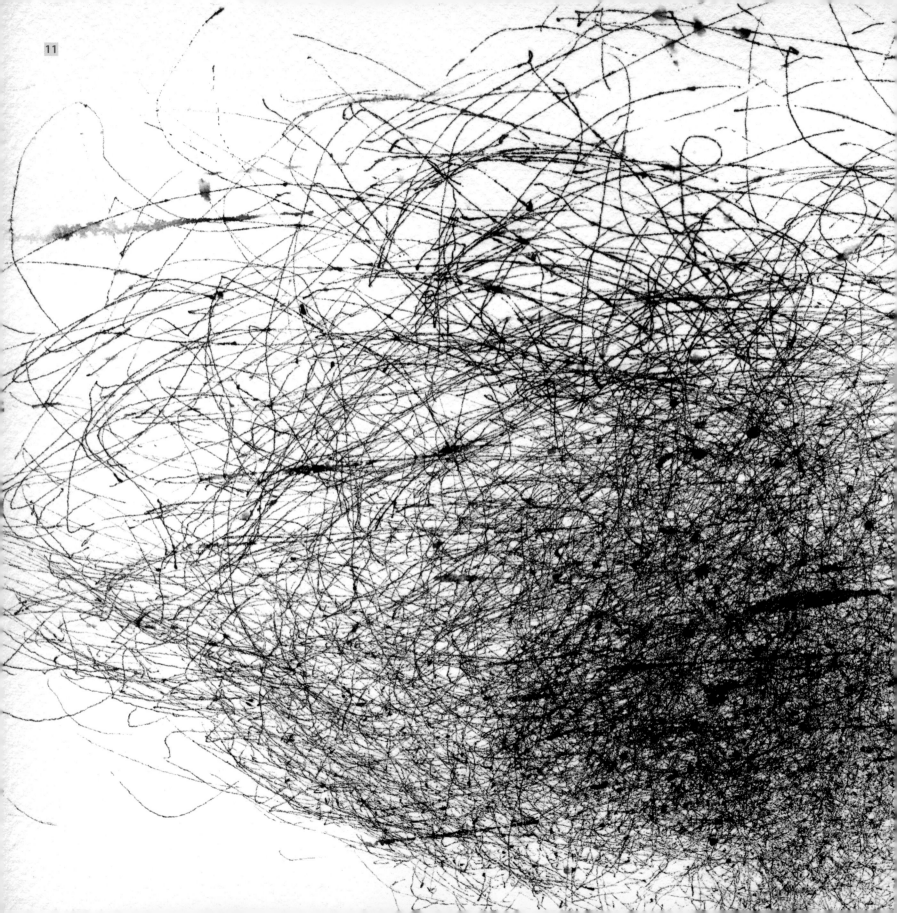

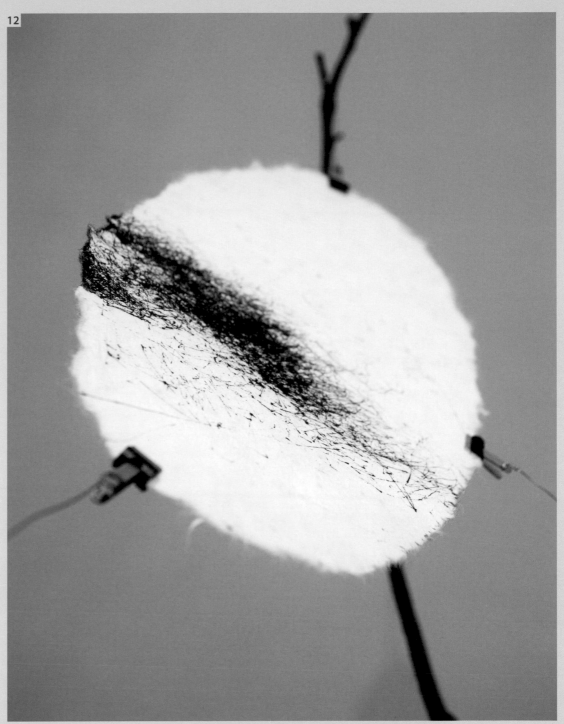

Fig. 11: Detail of finished wind drawing.
Fig. 12: One of Ueda's often intricate methods of displaying his wind drawings.
Fig. 13: Installation views of large wind drawings made on plastic in room 305. (Following pages)
Fig. 14: Detail of device used to make large wind drawings in fig. 13. (Following pages)

Additional image credit: Fig. 11 by Buff Ross.

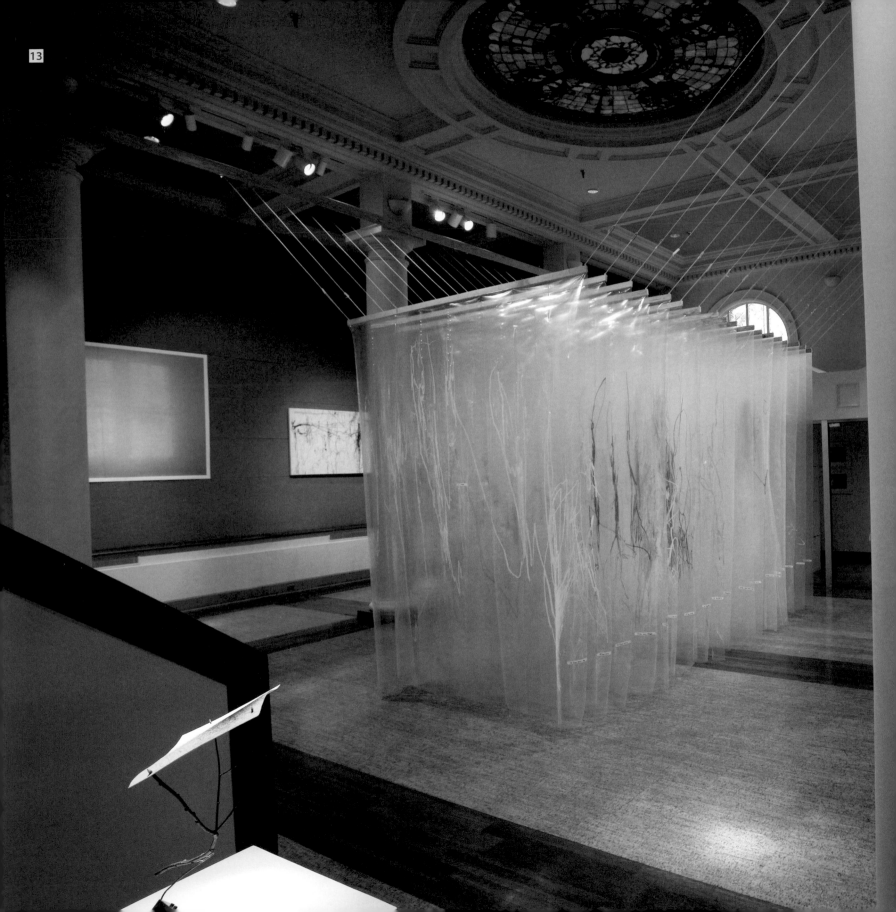

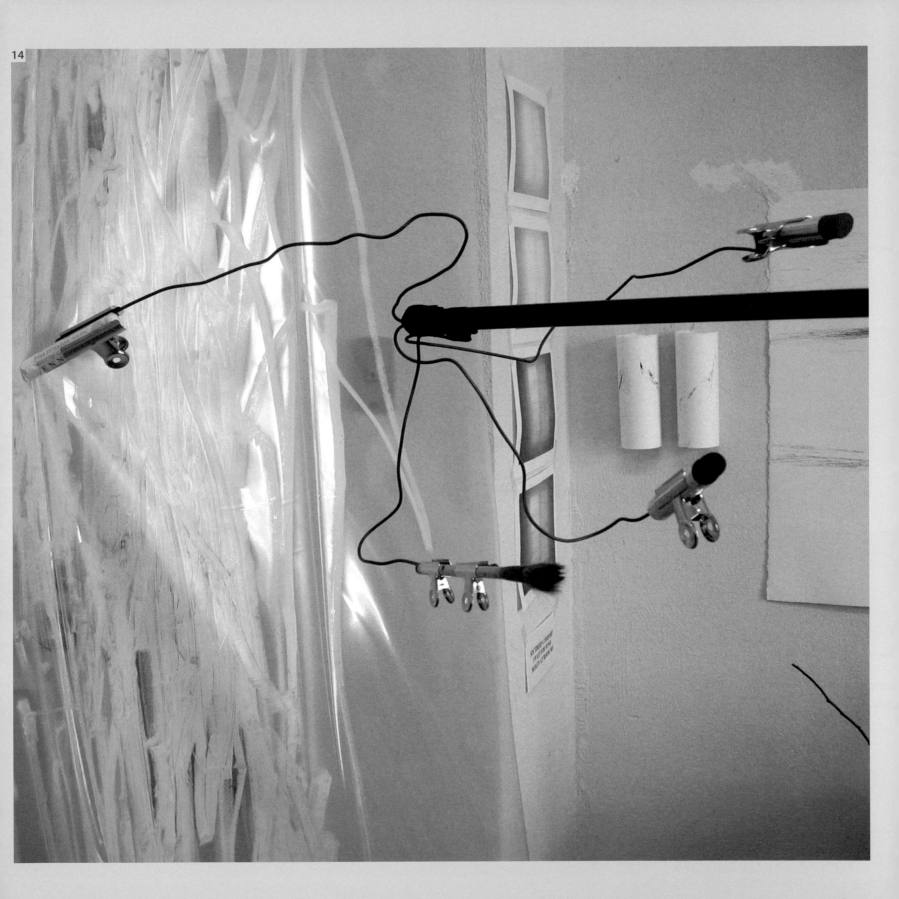

Motoi Yamamoto

Van Every/Smith Galleries at Davidson College
and
Halsey Institute of Contemporary Art

Displayed in the Sanders Rotunda in the Addlestone
Library at the College of Charleston

Born in Onomichi, Hiroshima, Japan, in 1966, Motoi Yamamoto worked in a dockyard until he entered school; in 1995, he received his B.A. from Kanazawa College of Art. He has had numerous exhibitions and residencies and won many prestigious awards. His works have been exhibited internationally: P.S. 1, New York; the 21st Century Museum, Kanazawa, Japan; the Israel Museum, Jerusalem; Maragopoulos, Patras, Greece; Contemporary Art International, Hamburg, Germany; Kunstmuseum, Thun, Switzerland; the Nunnery, London, England; Galleria Vittorio Emanuele, Milan, Italy; Sculpture Garden, Veracruz, Mexico; and many more. He was awarded a grant from the Pollock-Krasner Foundation in 2003, and won the Philip Morris Art Award in 2002. Motoi Yamamoto lives and works in Kanazawa.

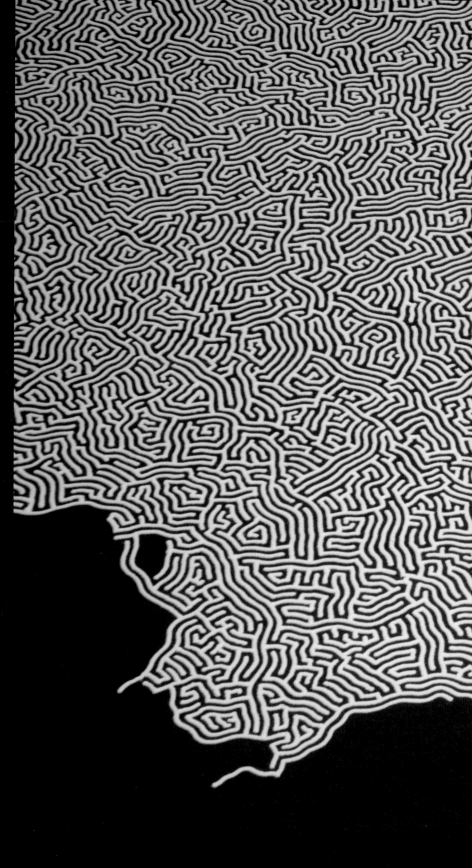

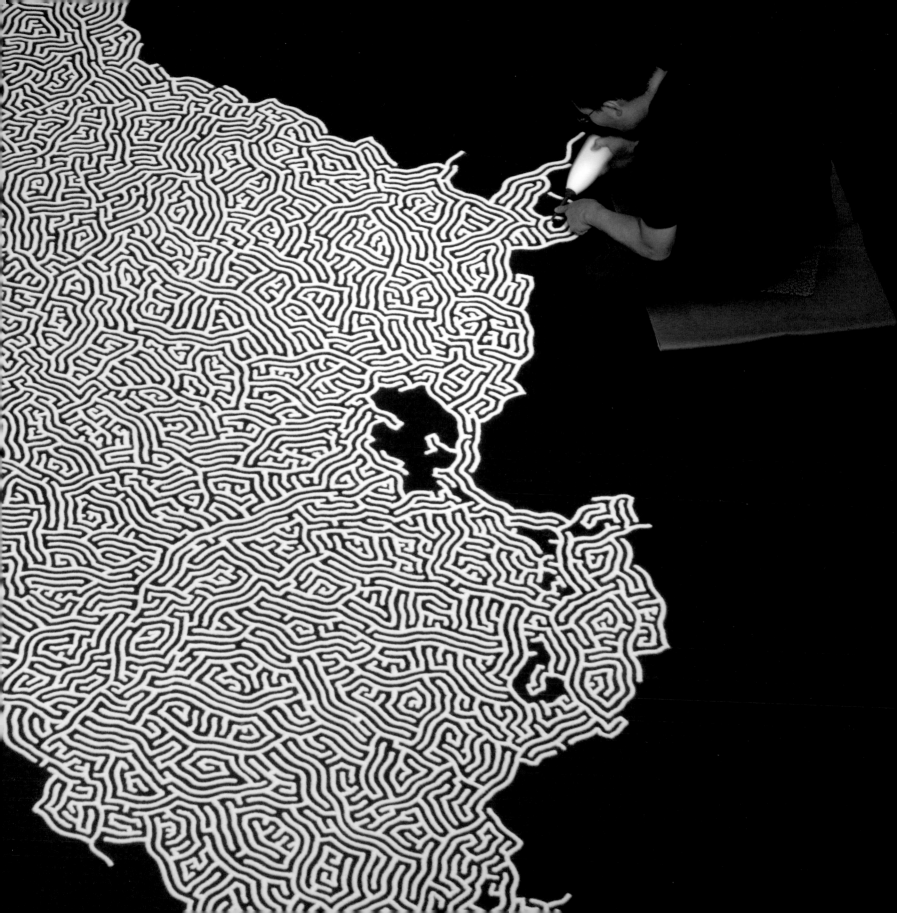

3

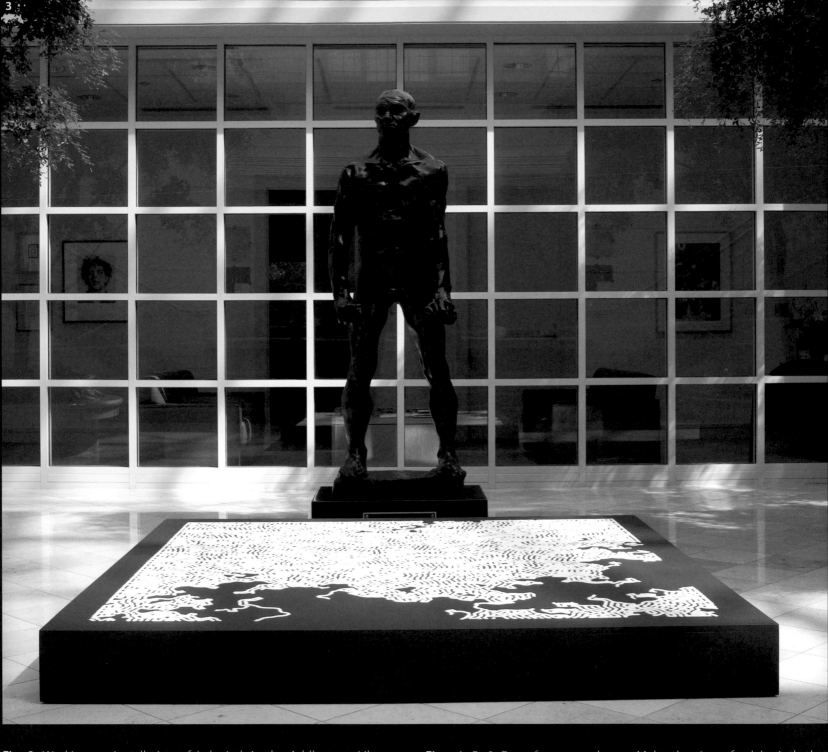

Fig. 2: Working on installation of *Labyrinth* in the Addlestone Library, College of Charleston. (Preceding page)

Fig. 3: Salt labyrinth in front of Rodin's *Jean d'Aire*, 1886, in the atrium of Davidson's Belk Visual Art Center.

Figs. 4, 5, 6: Forty-foot gouache on Mylar drawing of a labyrinth that hung in the atrium of Davidson's Belk Visual Art Center.

Labyrinth

Following the death of his sister from brain cancer twelve years ago, Motoi Yamamoto adopted salt as his primary artistic medium. In Japanese culture, salt is not only a necessary element to sustain human life, it is also a symbol of purification. He uses salt in loose form to create intricate labyrinthine patterns on the gallery floor or in baked-brick form to construct large interior structures. As with the labyrinths and unnavigable passageways, Motoi views his installations as exercises that are at once futile yet necessary to his healing.

Salt is a ubiquitous commodity; it is found in all the oceans of the world, and virtually all cultures use some variant in their diet. What began as an exploration of the practices of Japanese funerary culture and its use of salt has now become a more philosophical inquiry into the importance of this substance to life on the planet. Yamamoto likes to think that the salt he uses might have been a life-sustaining substance for some creature. He is interested in the interconnectedness of all living things and the fact that salt is something shared by all. For this reason, when his saltworks must be disassembled, he requests that the salt in his installation be returned to the ocean (figs. 13, 14, 15).

A labyrinth may be defined as "a path with a purpose." There is usually a beginning and an end point. A maze has intentional dead ends and false starts. On the surface, Yamamoto's works appear to fall into the category of a maze; however, it is his wish that viewers use his labyrinth installations as a tool for meditation and

4

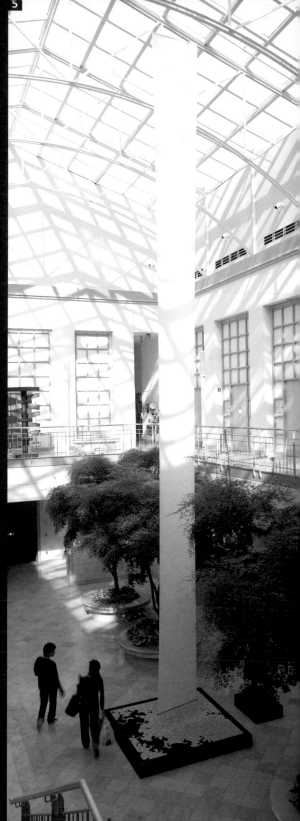

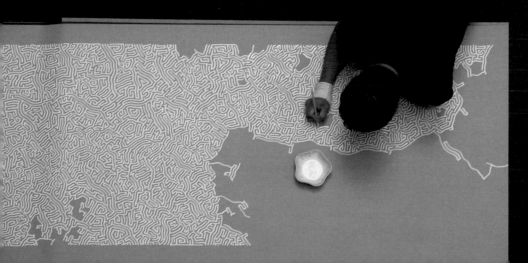

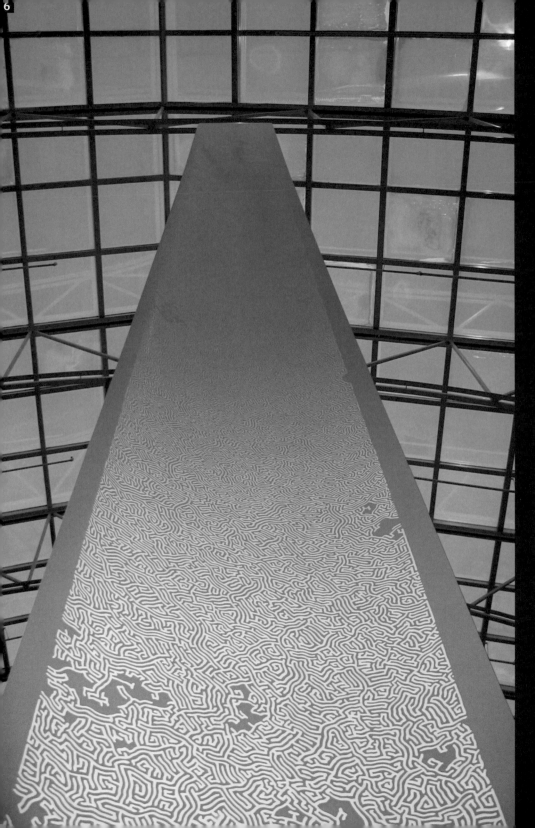

an opportunity to reach some final point in their own thoughts. The similarities between Yamamoto's drawings and the circuitry of the human brain are interesting. Knowing of his sister's illness, it is not surprising that there is a visual connection between the installations and the source of their inspiration.

According to the artist, "Drawing a labyrinth with salt is like following a trace of my memory. Memories seem to change and vanish as time goes by. What I seek, however, is the way in which I can touch a precious moment in my memories that cannot be attained through pictures or writings. I always silently follow the trace that is controlled as well as uncontrolled from the starting point after I have completed it." While working on these installations, Yamamoto is only concerned with the "line"; the focus of his attention cannot waver from that. When asked about the lack of permanence of his works, he states, "It does not matter if the work lasts or does not last. I use salt. It lasts as long as it will."

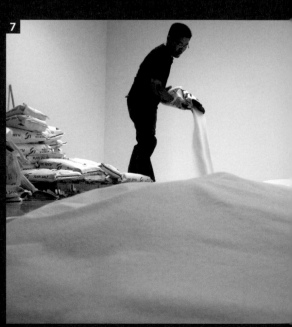

Figs. 7, 8: *Labyrinth* installation in Davidson's Smith Gallery.

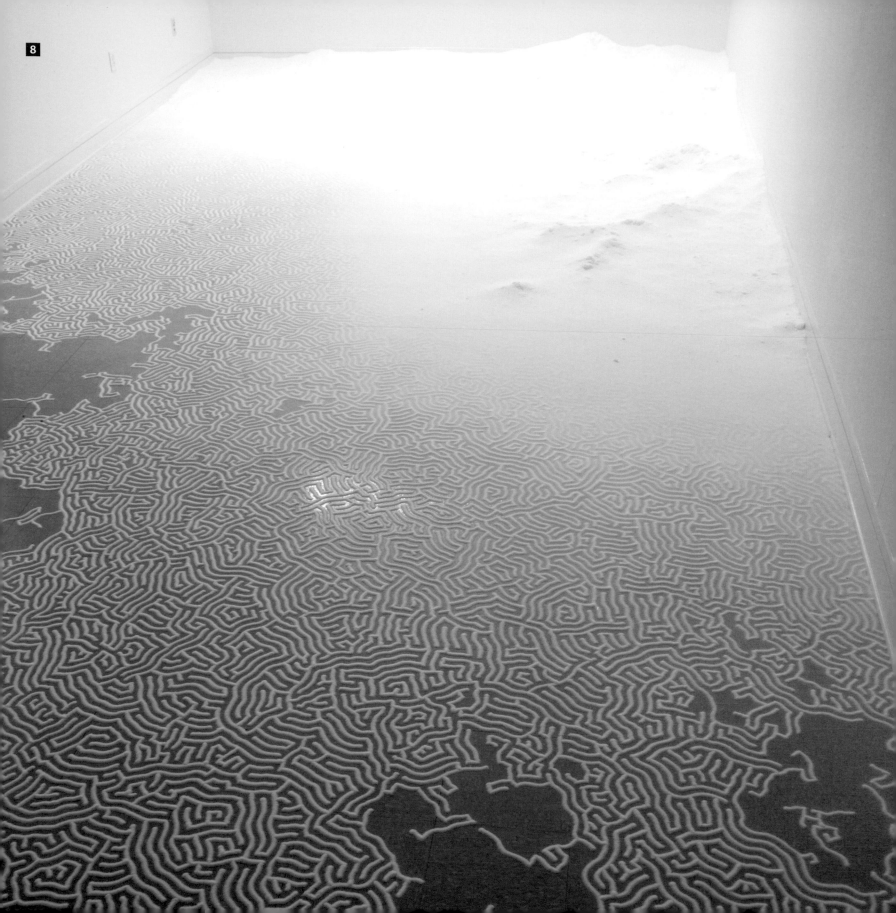

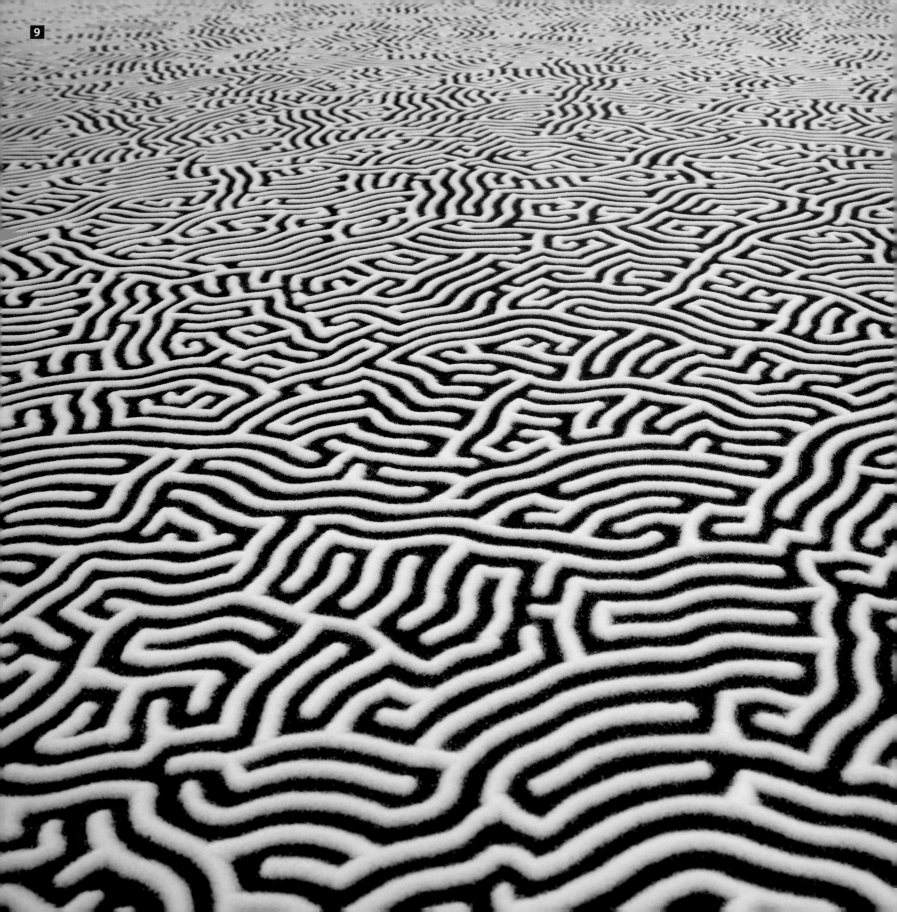

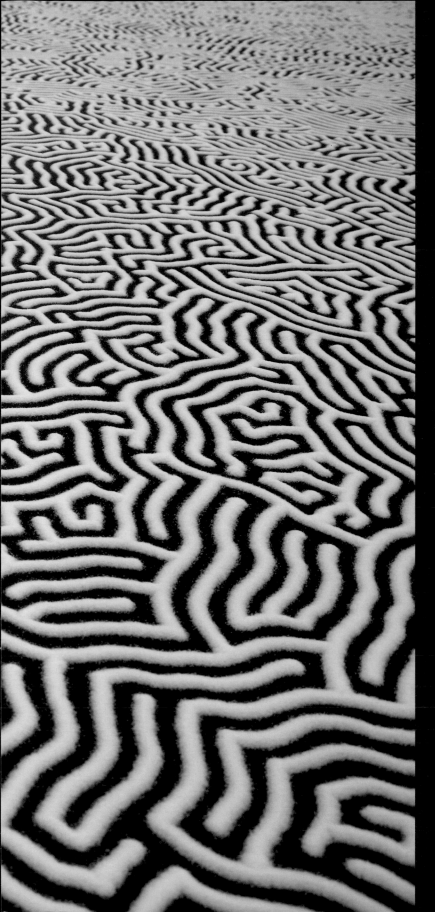

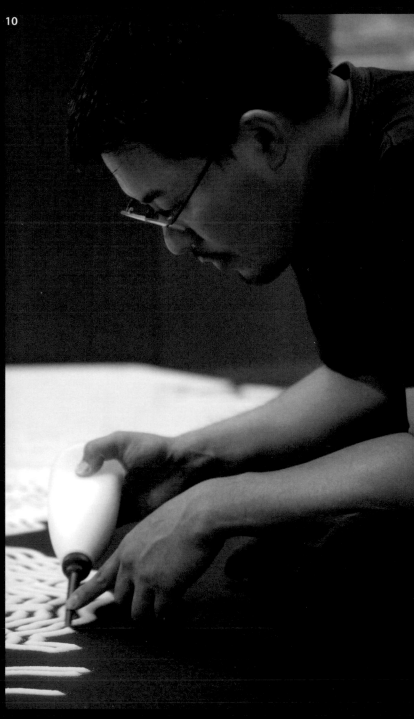

Figs. 9, 10, 12: *Labyrinth*, installed on a platform in the Sanders Rotunda in the Addlestone Library at the College of Charleston.
Fig. 11: Gouache on Mylar preparatory drawing for the installation. (Following pages)

Additional image credits: Figs. 4, 6, 7 by Brad Thomas and figs. 13, 14, 15 by Motoi Yamamoto.

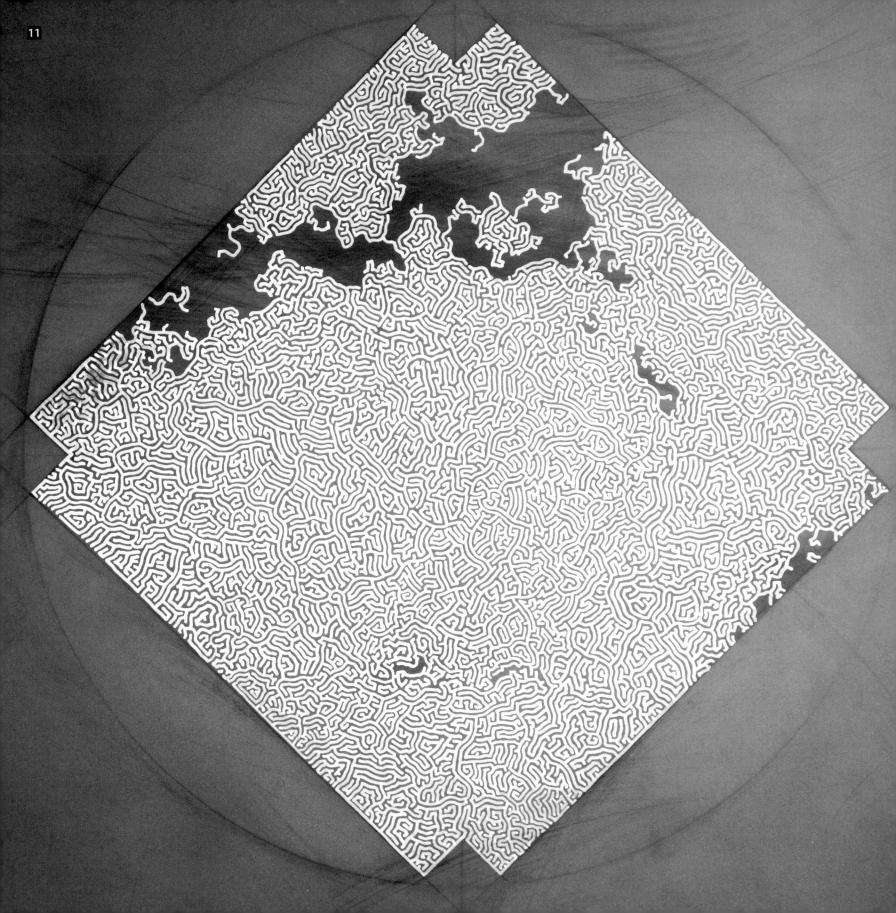

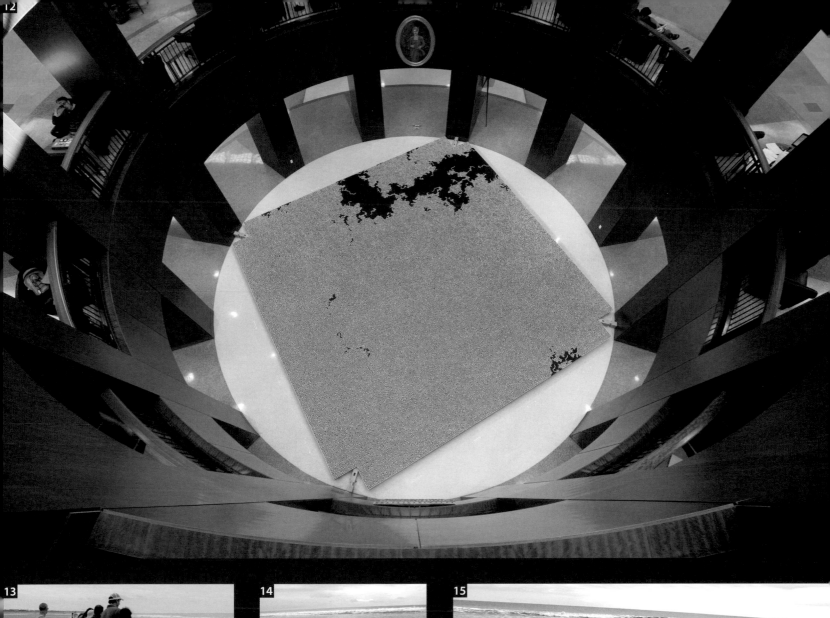

12

13

14

15

Figs. 13, 14, 15: Motoi returned all salt used in installations to the sea. Here, the Atlantic Ocean reclaimed the salt from his project.

Yumiko Yamazaki
Winthrop University Galleries

Born in Osaka, Japan, in 1963, Yumiko Yamazaki received her B.A. from Osaka University of Art in 1986 and her M.F.A. from Tama University of Fine Arts in 1988. She has had numerous exhibitions and residencies. Her residencies include the Mino Paper Art Village Project, Mino City, Japan, and Sumter Art Gallery, Sumter, South Carolina. Her works have been exhibited at the Museum of Modern Art, Rijeka, Croatia; American Museum of Papermaking, Atlanta, Georgia; Mino Paper Museum, Mino City, Japan; Setagaya Modern Museum, Tokyo; and many more. Yumiko Yamazaki lives and works in Osaka.

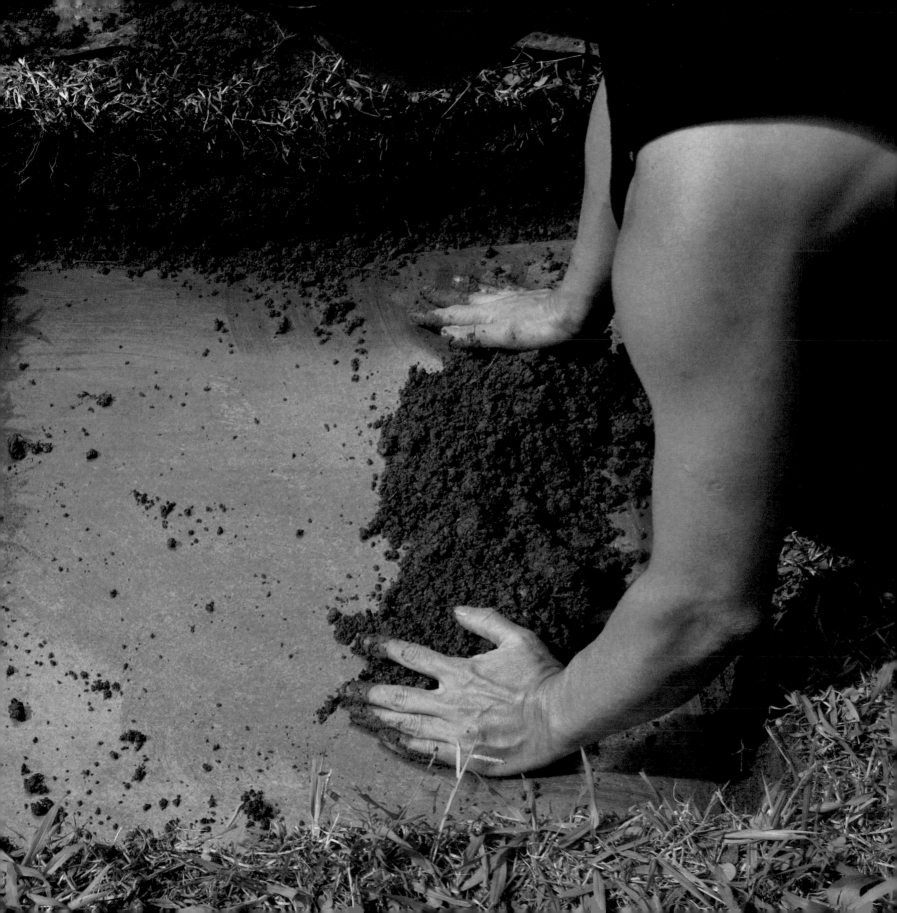

Remembrance of Time

Yumiko Yamazaki uses natural elements and the passage of time to create art that serves as a metaphor for the human experience of nature. To create this metaphor, she places copper plates underneath the earth to record the interaction of the living soil, plant life, and insects with the metal (figs. 1, 2, 3, 4, 5, 6, 7, 8). The sequence of photographs depicts the process of digging a hole, placing the 24-inch-square copper plate into the ground, burying it, and watering the surface to encourage nature to do its work.

In the 1990s, Yamazaki experienced a debilitating illness that kept her confined to her home for several years. She has very little memory of this "lost" time. She does remember marking time by the growth of the houseplants in her room. This observation has served as the inspiration for all of the work she has created since 1999, when she regained her health. Yamazaki is a conceptual artist who uses nature as her collaborator to create works that reveal the subtleties of our experience of time.

The Chinese philosophical concept of yin and yang is an important component of Yamazaki's work. Three of the copper plates were buried in shady, hard-to-get-to locations on the Winthrop campus (yin), and three were buried in high-traffic, sunny locations (yang). She was interested in seeing if the resulting corrosion on the plates was different, given the different character of the locations. After meticulously polishing each copper plate, Yamazaki carefully placed it in its respective location, then covered it with soil. This ritualistic process was an attempt to capture a record of the artist's time here with *Force of Nature*.

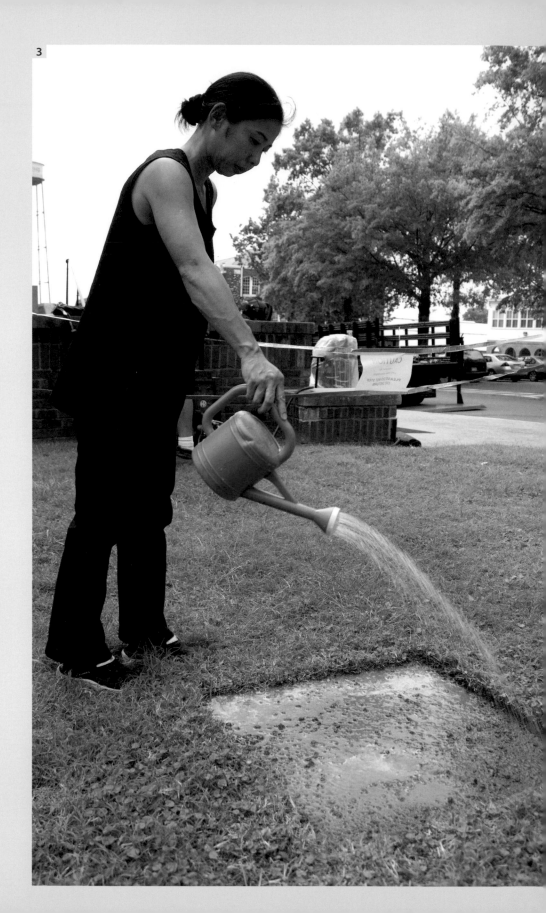

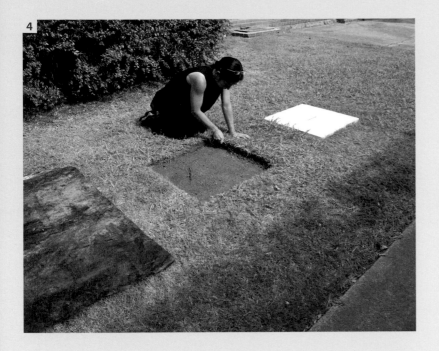

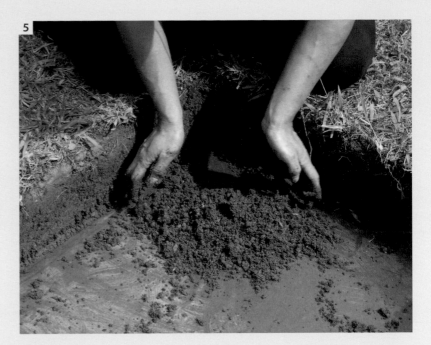

The resulting works were a composite of all of nature's elements as they acted on the earth, the plates, and the artist.

Yamazaki documented the process of her *Force of Nature* project with photos that she posted on her personal web site. Then, after three weeks, she unearthed the copper plates and used them for a series of large-scale prints. She also created a series of sheets of handmade paper incorporating all living things that grew above the buried copper plates (fig. 9). The artist meticulously collected plant material from the sites to incorporate into the handmade paper (figs. 10, 11).

Patience is an ally in this artist's toolbox. She eagerly awaits the growth of the smallest blades of grass or plant forms, yet she knows that nature has its own time frame. She is not interested in controlling nature with her projects—rather, she seeks to allow nature to do what it does. Waiting is a necessary artistic activity.

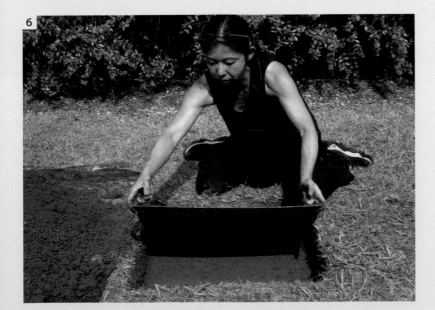

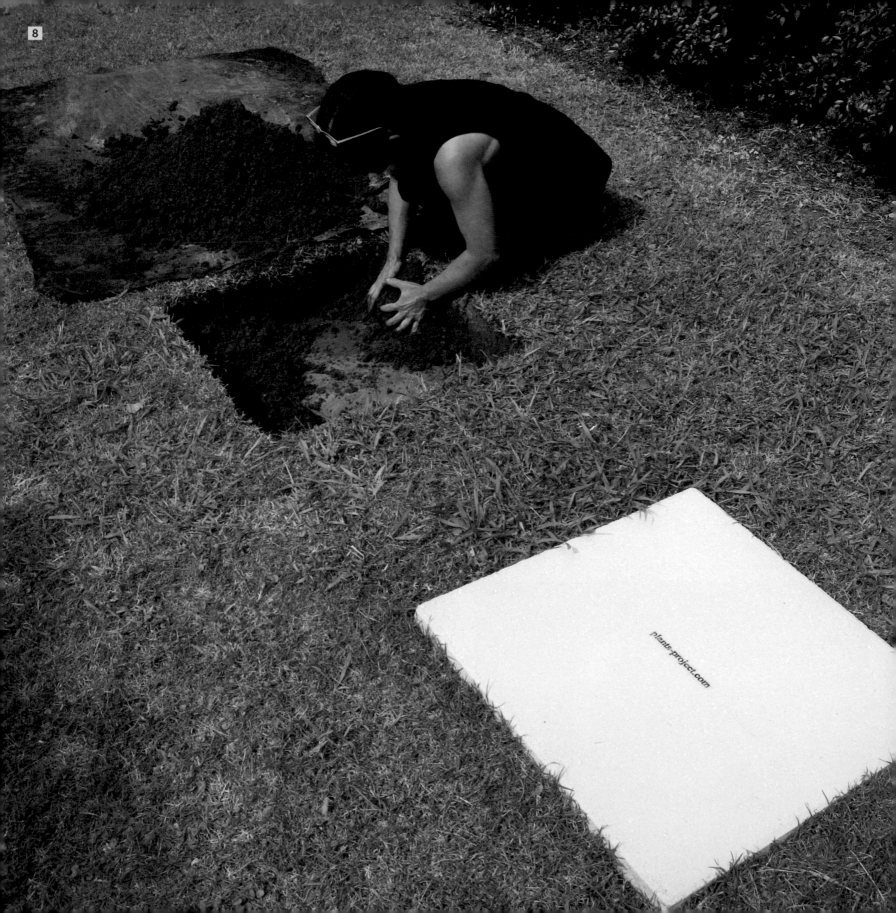

plants-project.com

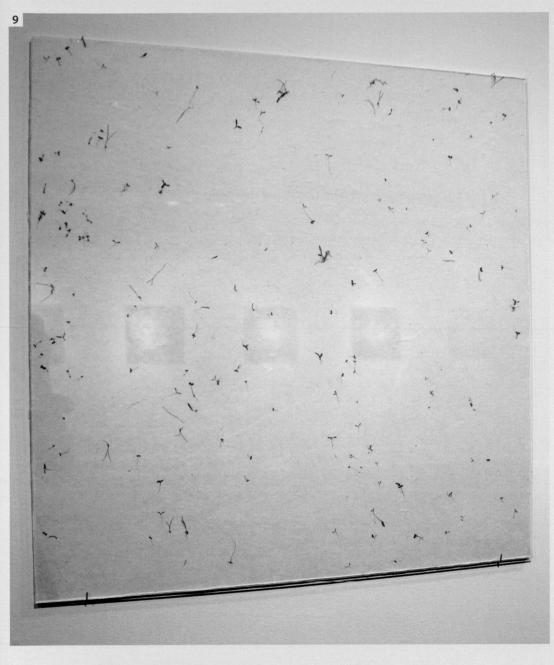

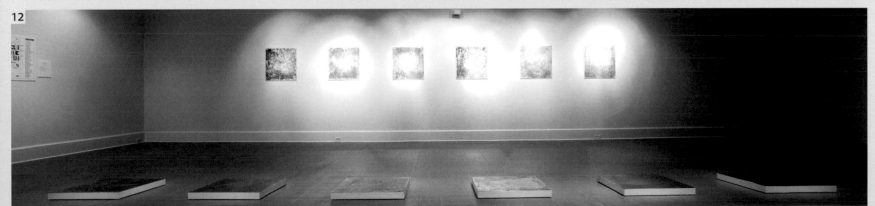

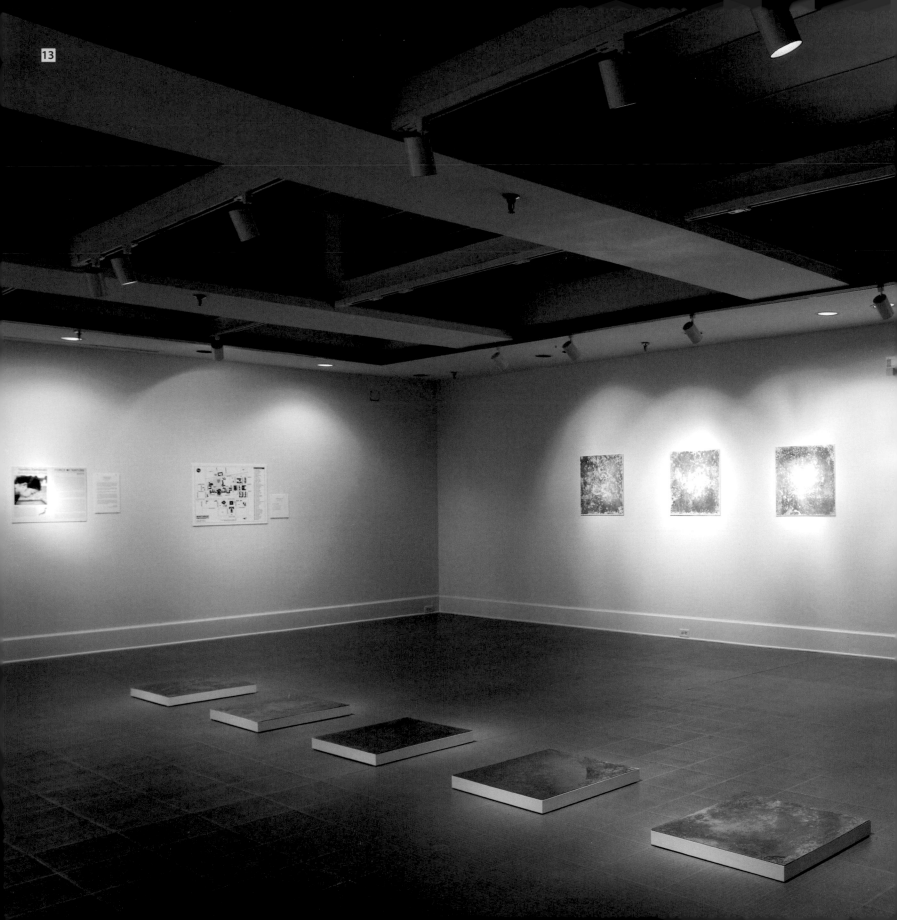

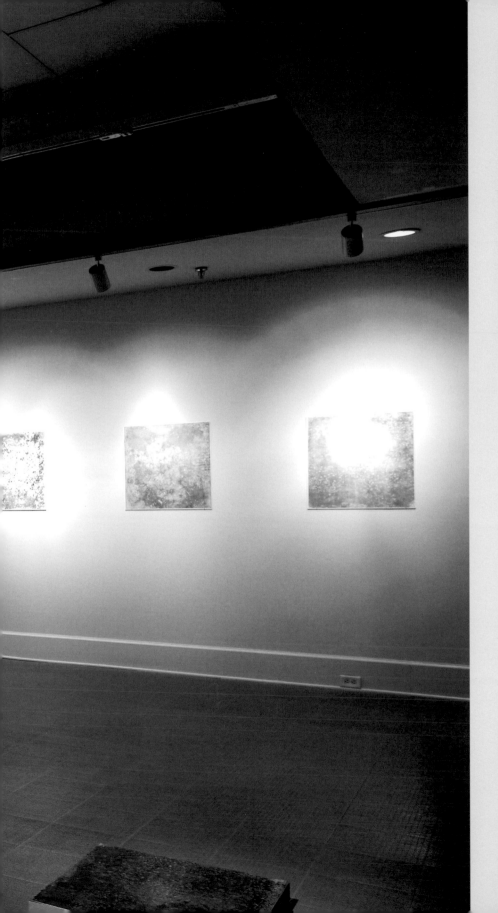

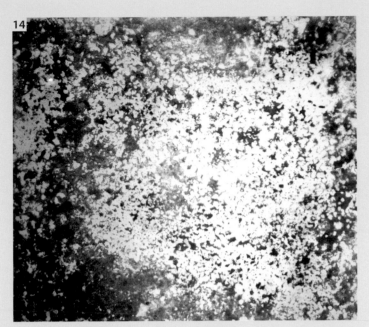

Figs. 12, 13, 16, 17: Installation views showing copper plates on the floor, prints made from those plates on one wall, and paper made from plant life growing above individual plates on the opposite wall.

Figs. 14, 15: Prints from unearthed plates.

Additional image credit: Figs. 10, 11 by Karen Derksen.

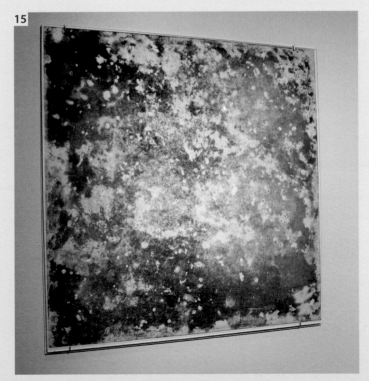

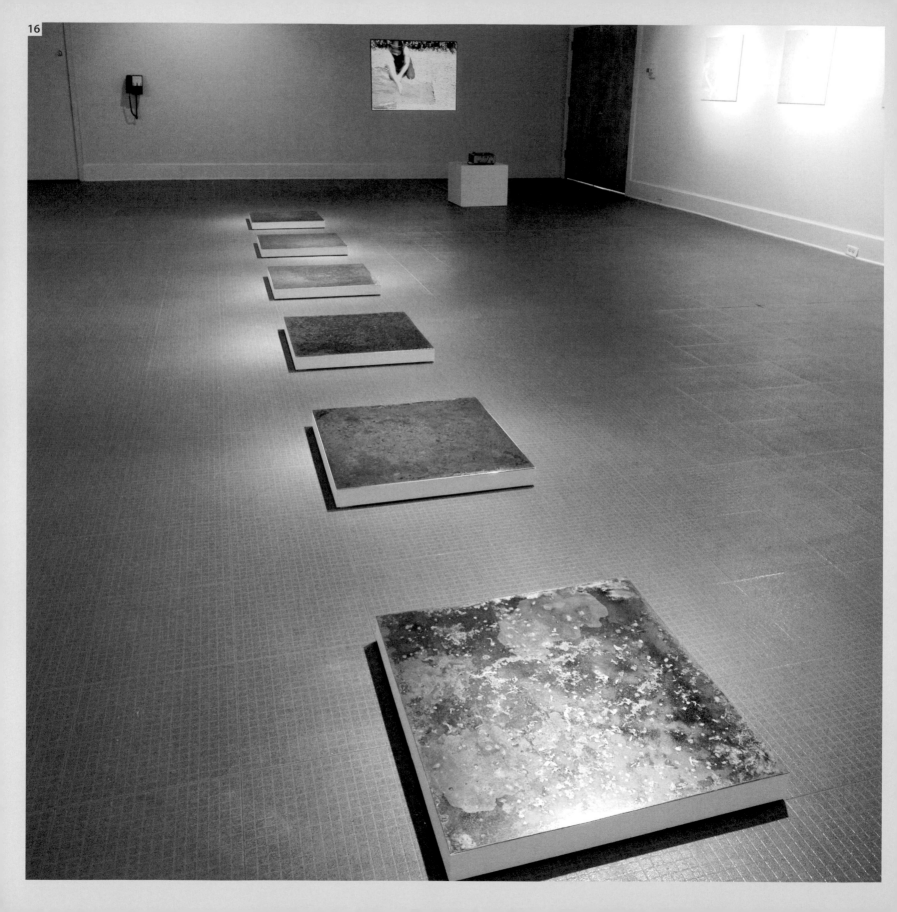

16

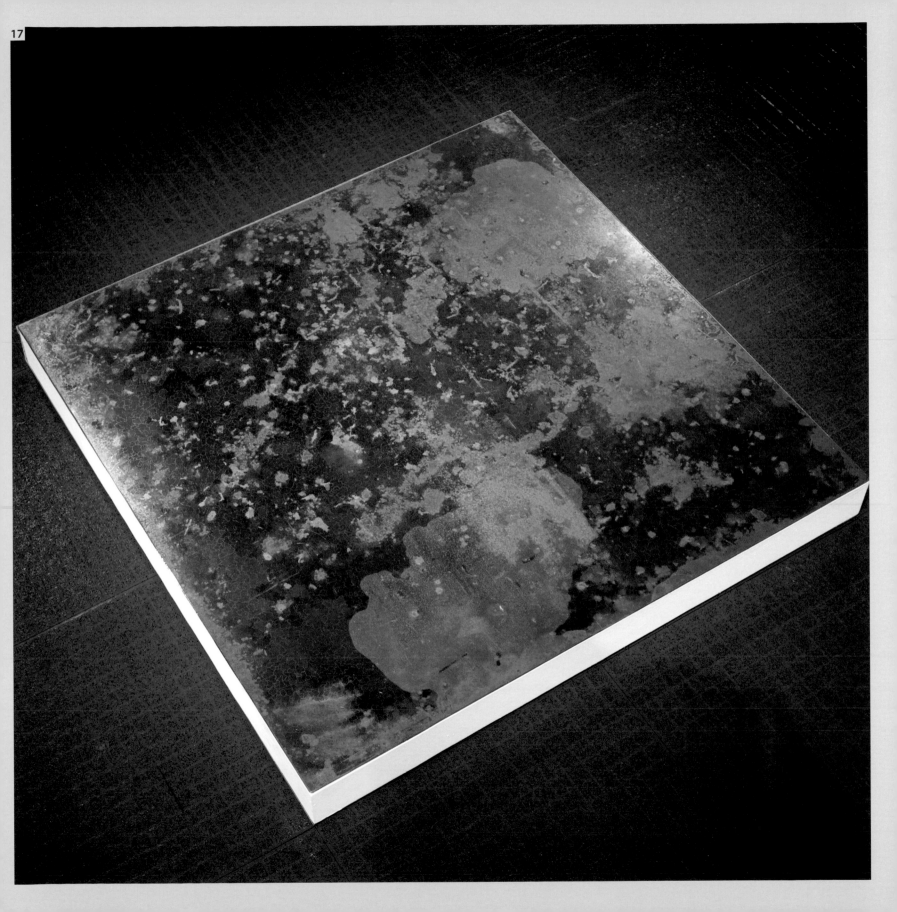

Appendices

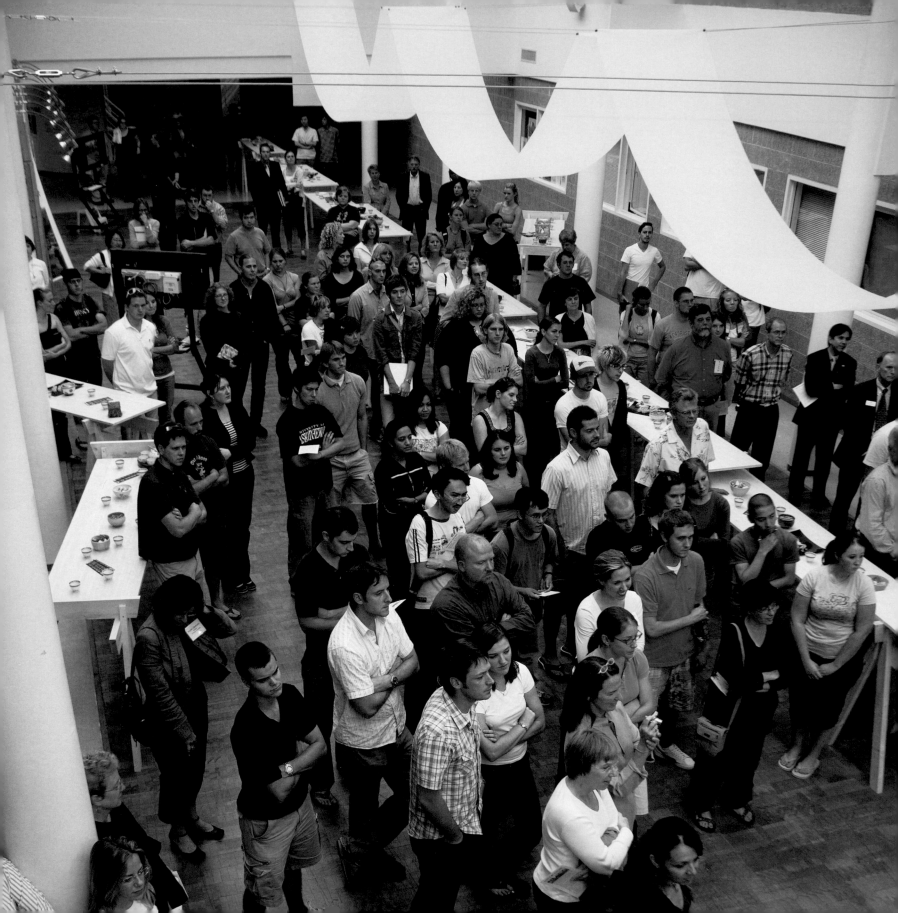

Sponsors

The National Endowment for the Arts
American Tire Distributors, Inc.
SunTrust Banks
The Henry Luce Foundation
Arts & Science Council of Mecklenburg County
North Carolina Arts Council
Asian Cultural Council
Sumter County Cultural Commission
Greater Sumter Chamber of Commerce
The Freeman Foundation
Thompson-Turner Construction

NATIONAL
ENDOWMENT
FOR THE ARTS

A great nation
deserves great art.

www.ncarts.org

ARTS &
SCIENCE
COUNCIL

Advancing Arts, Science & History

THE HENRY LUCE
FOUNDATION

asian
cultural
council

Partners

Project Personnel:

Mark Sloan, Cocurator
Brad Thomas, Cocurator
Noriko Fuku, Associate Curator
Katherine Borkowski, Project Manager
Kana Kobayashi, Project Translator in the United States
Buff Ross, Project Graphic Designer and Webmaster

Institutional Partners:

Halsey Institute of Contemporary Art at the College of Charleston
Mark Sloan, Director and Senior Curator
Katie Lee, Assistant Director and Curator

The Halsey Institute of Contemporary Art is administered by the School of the Arts at the College of Charleston and exists to advocate, exhibit, and interpret visual art, with an emphasis on international contemporary art. HICA is committed to providing a direct experience with works of art in all media within an environment that fosters creativity, individuality, innovation, and education. In addition to housing exhibitions, HICA serves as an extension of the undergraduate curricula and sponsors artist residencies, lectures, films, symposia, and other interpretive programs. While the primary audiences served include the College's students, faculty, and staff, the Halsey Institute of Contemporary Art is open to the public, whose participation in its programs is encouraged.

HALSEY INSTITUTE
OF CONTEMPORARY ART

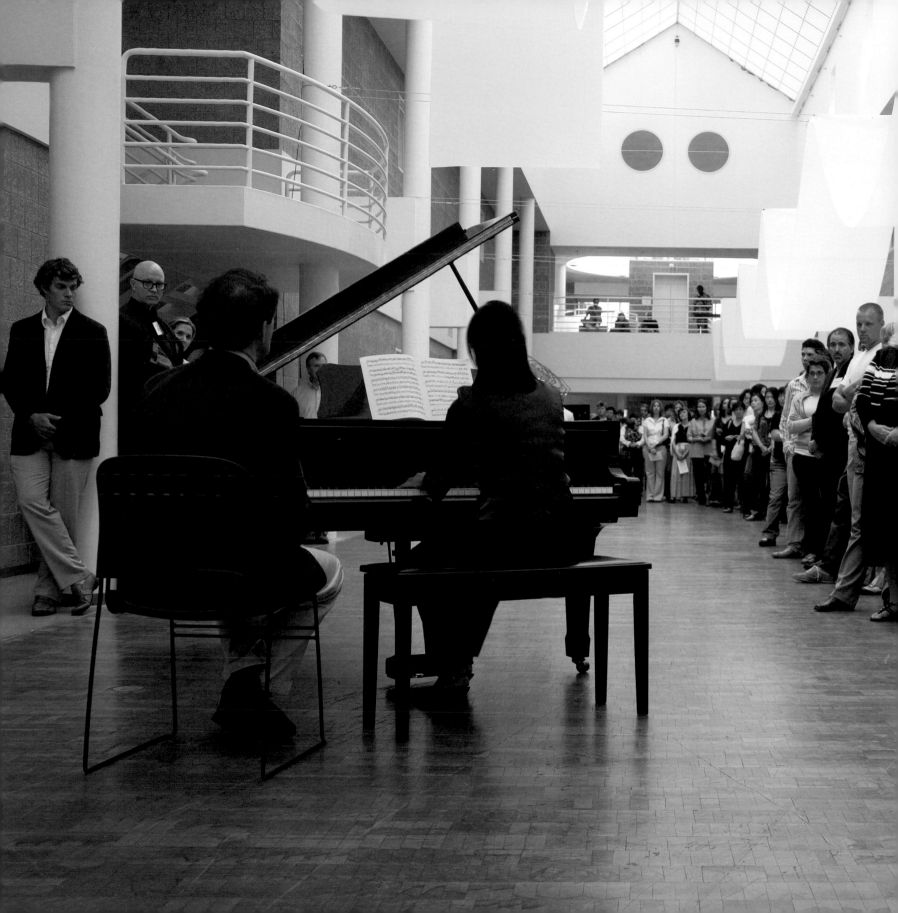

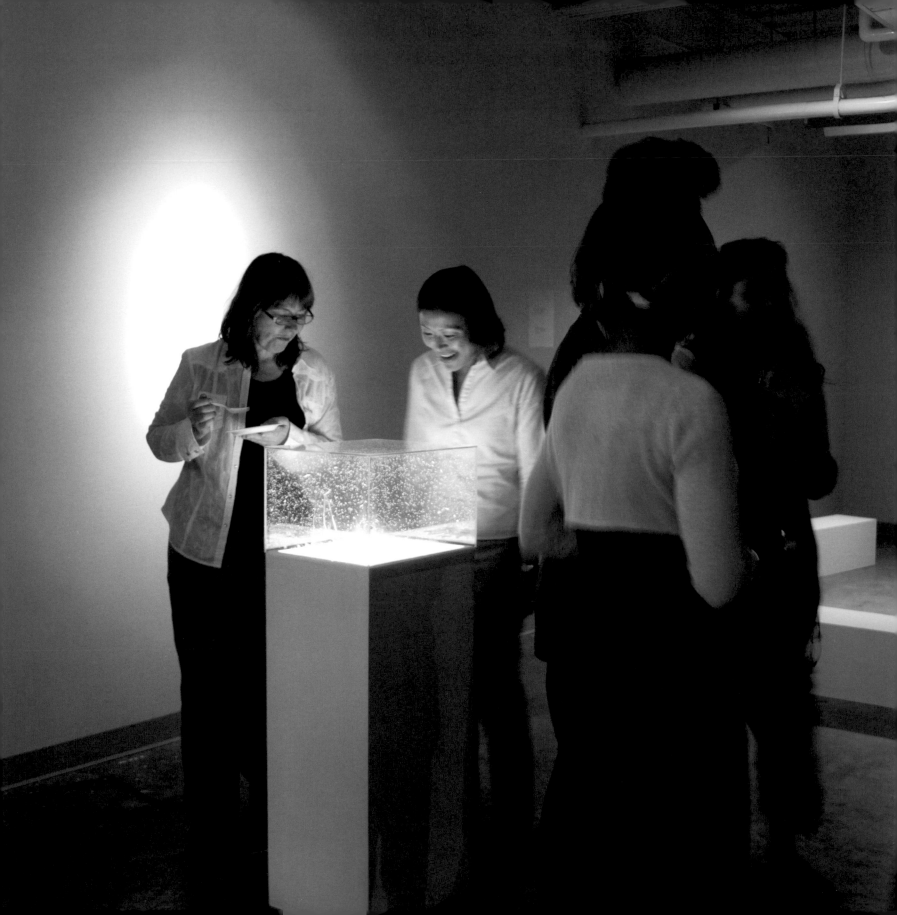

Van Every/Smith Galleries at Davidson College

Brad Thomas, Director and Curator
Jessica Cooley, Assistant Curator

The Van Every/Smith Galleries play a fundamental role in the pedagogical life of Davidson College. The galleries provide a challenging forum for the presentation, interpretation, and discussion of primarily contemporary artworks in all media for students and members of the Davidson community, as well as for national and international visitors to the campus. In addition, the Permanent Art Collection of 2,800 works serves as a research center by offering students and members of the Davidson community an opportunity to interact with works of art that span five centuries. An ongoing series of exhibitions and lectures by visiting artists and scholars nurture individual thinking, develop visual literacy, and inspire a lifelong commitment to the arts.

College of Architecture at the University of North Carolina-Charlotte

Ken Lambla, Dean
Jessica Thomas, Graduate Assistant

The mission of the College of Architecture is to provide—through excellence in teaching, scholarly research, creative architectural practice, and community activism—intellectual, ethical, and innovative leadership in architecture and urban design.

Faculty and students at the College of Architecture are committed to creating an open-minded and creative atmosphere to pursue research, explore new forms of building, and discover collaborative practices that nurture human potential. Our graduates understand where knowledge comes from and how to integrate their voice with others to influence the art and science of architecture. The College of Architecture opens opportunities to students through interdisciplinary programs, close alliances with the profession, and active programs in the community.

Clemson Architecture Center in Charleston
Robert Miller, Professor and Director
Mary Martin Walker, Administrative Assistant

Architects and students from all over the world visit Charleston to learn about its unique character. Twenty years ago, we decided that it was essential for the only school of architecture in the state to have a program there. What started as a small undergraduate studio is now well on its way to becoming a comprehensive fifty-student center that includes graduate studies in collaboration with the College of Charleston, the American College of the Building Arts, and with very strong links to the profession. The Charleston program, along with other centers in Italy and Spain, contributes to the concept of a fluid campus and the globalization of programs that the Clemson Architecture Center seeks, where every student has the opportunity for an enriching experience away from the main campus.

Winthrop University Galleries
Tom Stanley, Director
Karen Derksen, Collections

The mission of the Winthrop University Galleries is to inform and enrich the lives of Winthrop students, faculty, and staff, as well as regional audiences, through the presentation of exhibitions and educational programs that celebrate artistic achievement. WUG promotes academic excellence and human understanding through visual art and design within the learning environment of a distinctive public comprehensive university.

McColl Center for Visual Art
Suzanne Fetscher, President
Ce Scott, Director of Residencies and Exhibitions

McColl Center for Visual Art is a Creative Crucible.

A place where sparks fly, metals fuse, ideas soar, paint comes alive, clay and cement take on form, neon glows, and creativity explodes! Our mission is to advance artists to the vanguard of contemporary art while enriching and engaging our community in the creative process.

The Center provides transforming experiences for visual artists, individuals who visit the Center, and our broader community.

Sumter County Gallery of Art
Karen Watson, Executive Director
Mark McCleod, Assistant Director and Curator

The Sumter County Gallery of Art is housed in a newly renovated state-of-the-art facility adjacent to Patriot Hall. SCGA is a nonprofit art institution and features rotating shows of both traditional and contemporary art by local, regional, and nationally recognized artists. Our three formal exhibition galleries are considered by many in the South Carolina arts community to be the best exhibition spaces in the state.

Acknowledgments

A project of this magnitude and complexity involves the close cooperation of a cast of thousands. The curators wish to acknowledge the tremendous contributions of the artists, partners, and sponsors, as well as all the persons and groups listed below:

Halsey Institute of Contemporary Art at the College of Charleston
Addlestone Library
Department of Asian Studies
Department of Historic Preservation and Community Planning
Office of Academic Experience
Office of Diversity
School of the Arts
School of Humanities and Social Sciences
School of Languages, Cultures, and World Affairs
Cone 10 Studios for the creation of ceremonial tea bowls
Ivan Berejkoff
Jenny Bloom
Jarod Charzewski
Dean David Cohen
Walter Crocker
Greg Dearing
Yvette Dede
Kathë Downs
President Conrad Festa
Claire Fund
Jonathan Gaynor
Former President Leo Higdon
John Jacob
Erik Johnson
Provost Elise Jorgens
Katie Lee
Diane and Rus Miller
Dean Valerie Morris
Bette Mueller-Roemer
Orinda Group Website Development
Leila Ross
Herb Parker
Alix Refshauge
Sue Sommer-Kresse
Michelle Van Parys

Van Every/Smith Galleries at Davidson College
David Boraks
Jessica Cooley
Marilyn and Irv Dix
Kirk Fanelly
Christa Faut
Rick Fitts
Brenda Flanagan
Dick Johnson
Fuji Lozada
Sarah Moore
Shelley Rigger
Cort Savage
Nancy Smith
Laura Southwell
President Bobby Vagt
Gavin Weber

**College of Architecture
at the University of North Carolina-Charlotte**
Department of Art
Department of Foreign Languages
Office of International Programs
Taylor Clay Products, Inc.
Marian Beane
Steve Blankenbeker
Keith Bryant
Chancellor Philip Dubois
Phil Gaddy
Francis Hawthorne
Fumie Kato
Provost Joan Lorden
Kaori Miyashita-Theado
Chikako Mori
Matt Parker
Rich Preiss
Shinichi Shoji
Azusa Suggs (CoA '06)
Nozomi Takano
Kanako Taku
Charles D. Taylor, Jr.
Jessica Thomas
Jason Tselentis
Shinobu Urita

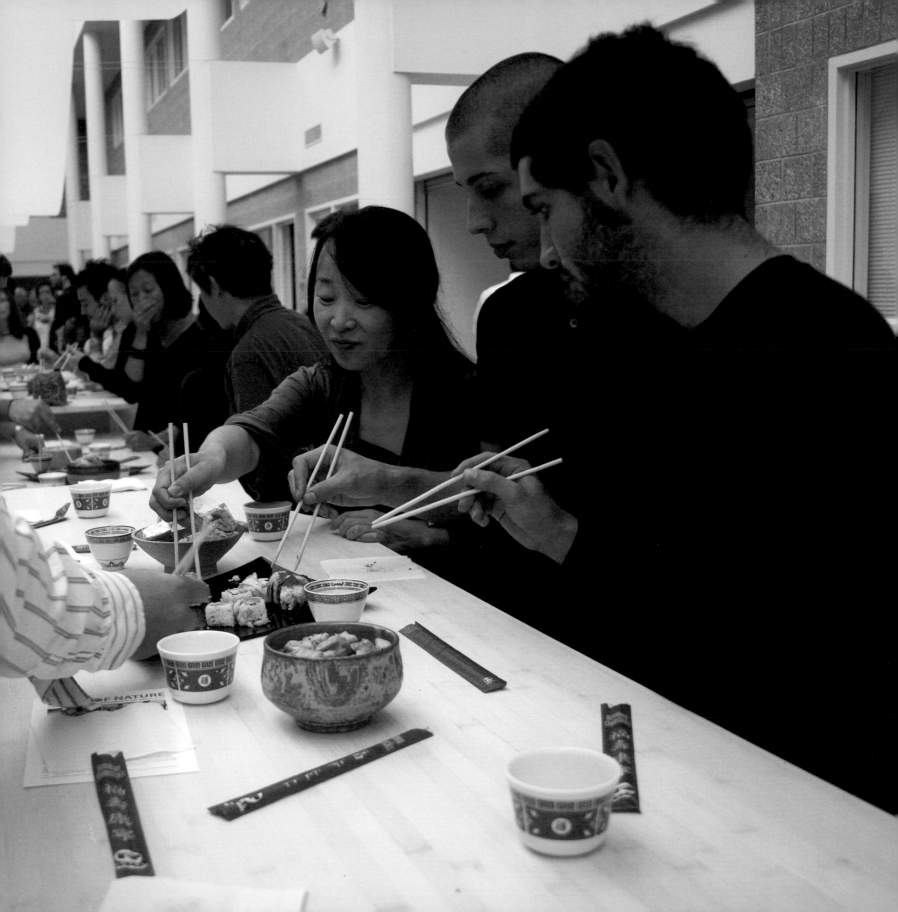

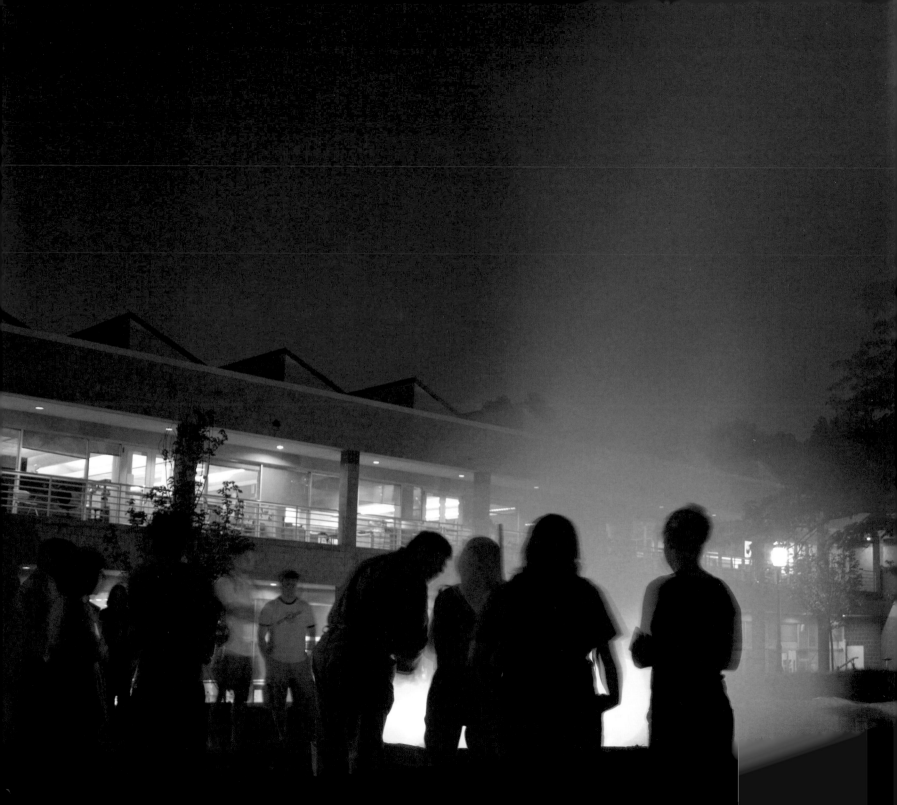

Clemson Architecture Center in Charleston
Clemson University
Aaron Bowman
Nic Fonner
Paul Kennedy
Michael Kreha
Brandon Walter
Jenny Williams

Winthrop University Galleries
Winthrop's International Center
Frank Ardaiolo
Shaun Cassidy
Tomoko Deguchi
Kim Dick
Paul Martyka
Tom Moore
Janice Mueller
Ronald Parks
Libby Patenaude
Nozomi Takano

McColl Center for Visual Art
Auston Davie
Scott DeHart
Claudia Gonzalez-Griffin
David Hill
Dennis Lemmons
Devlin McNeil
Sanako Ushiki

Sumter Gallery of Art
Community Resource Bank
Greater Sumter Chamber of Commerce
Kaydon Corporation
SCGA Board of Directors
SCGA Exhibits Committee
Sumter County Cultural Commission
Summit Realty and Development
The Copy Shop
The Item
Turner-Thompson Construction
Heidi Adler
Booth Chilcutt
Peggy Chilcutt
Amanda Cox
Sayuri Demuynck
Barbara Finley
Les Gray
Martha Greenway
Charlie Holmes
Audrey Maple
William Prince
David Shoemaker

We wish to thank Harriet Green and the staff of the South Carolina Arts Commission for providing meeting space for project partners on several occasions.

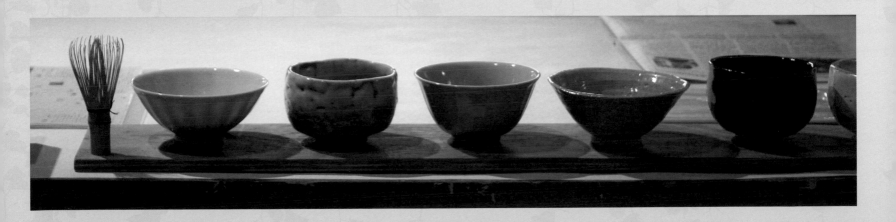

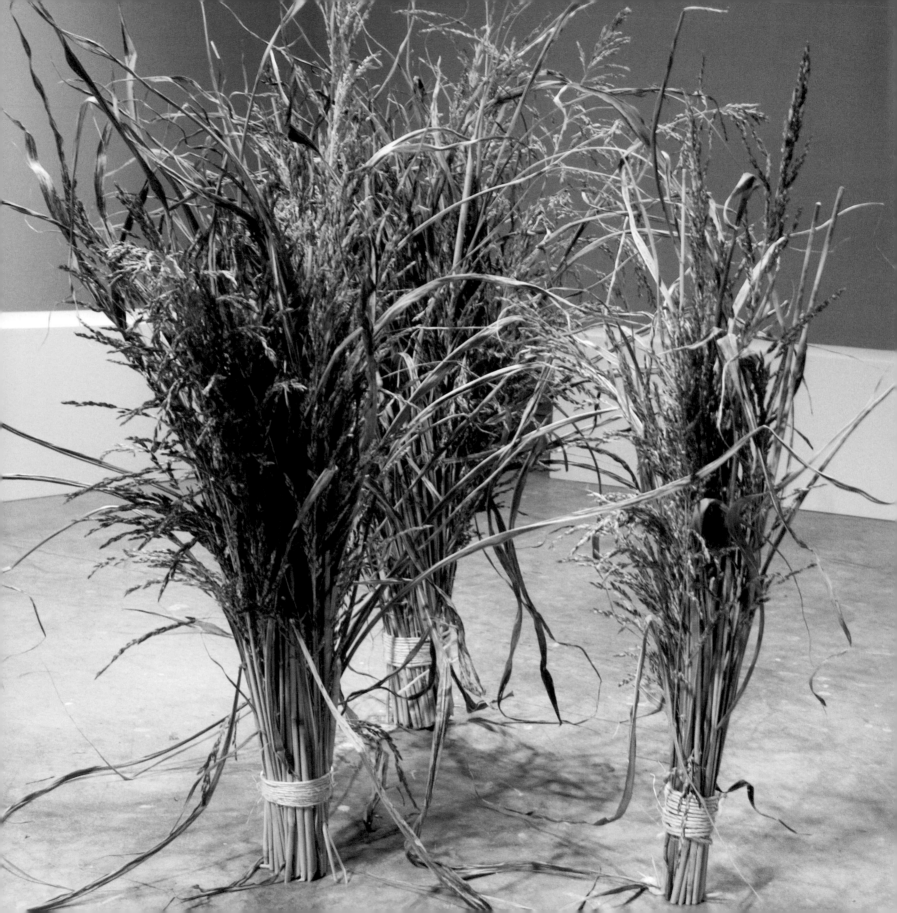

mark sloan

Mark Sloan is an artist, author, curator, and educator. He has been the director and senior curator of the Halsey Institute of Contemporary Art at the College of Charleston since 1994. He has written (or cowritten) six books of literary nonfiction, among them *Self-Made Worlds: Visionary Folk Art Environments* (Aperture, 1997), and *Wild, Weird, and Wonderful: The American Circus 1901–1927 as Seen by F. W. Glasier, Photographer* (Quantuck Lane Press/W. W. Norton & Co., 2003). He has produced traveling exhibitions and monographs on the work of Russian artists Rimma Gerlovina and Valeriy Gerlovin: *PHOTOGLYPHS* (New Orleans Museum of Art, 1993); *Juan Logan: Effective Sight* (Green Hill Center for North Carolina Art, 1994); and *Evon Streetman: Black Boiled Coffee and the Cacophony of Frogs* (Halsey Institute, 2000). As an artist, his works have been shown in exhibitions at the High Museum of Art in Atlanta, and the Grand Palais in Paris.

brad thomas

Brad Thomas is an artist and director of the Van Every/Smith Galleries at Davidson College. He is the recipient of both a North Carolina Arts Council Visual Artist Fellowship and New Works Grant. His works are in numerous private and public collections, among them the Whitney Museum of American Art and the U.S. Federal Reserve. As a curator, he has organized exhibitions, including the retrospective of apocalyptic visionary paintings by the late Reverend McKendree Robbins Long and a presentation of narrative textiles by indigenous peoples of war-torn countries, entitled *Threads of Conflict*. His critical reviews have appeared in the *Chicago Tribune*, and, most recently, he has authored catalogues for survey exhibitions of works on paper by Robert Lazzarini and large earth-based sculptures by Thomas Sayre.

noriko fuku

Associate curator Noriko Fuku is a professor at Kyoto University of Art and Design. As an independent curator, she has organized major exhibitions by artists David Byrne, Keith Haring, Robert Mapplethorpe, Catherine Opie, Man Ray, and Cindy Sherman. She has also organized many exhibitions of Japanese artists, including *Land of Paradox: Yuji Saiga, Naoya Hatakeyama, Norio Kobayashi, and Toshio Yamane*.

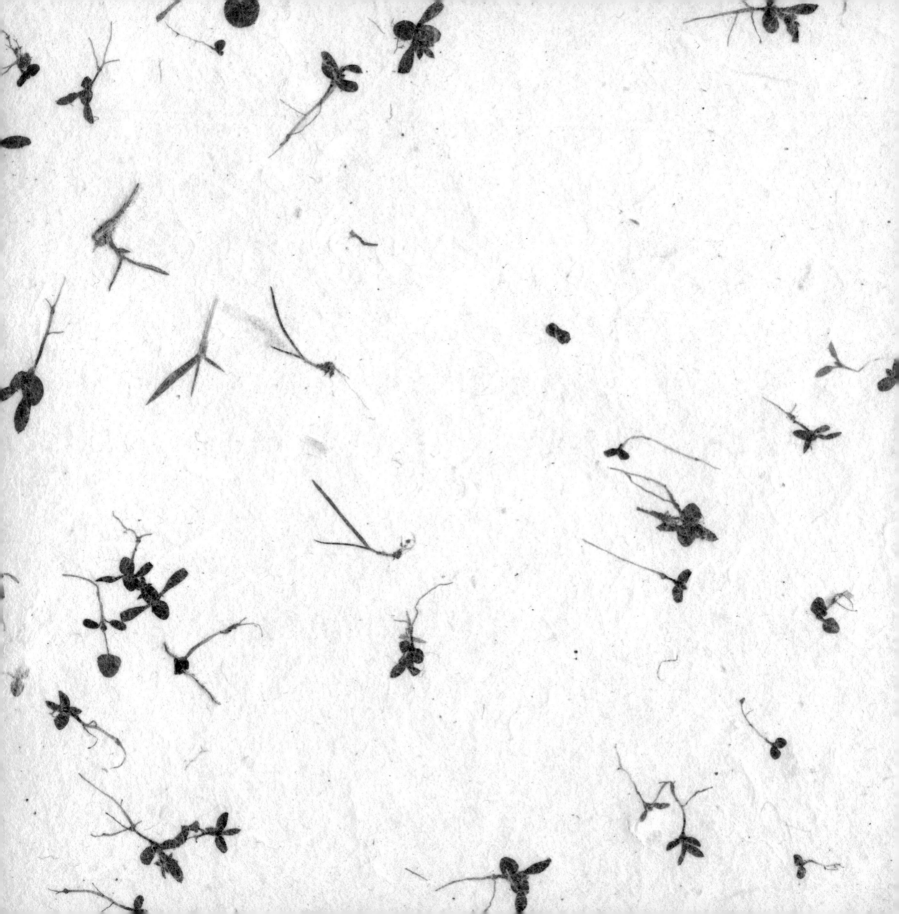